WILD

TULARE COUNTY

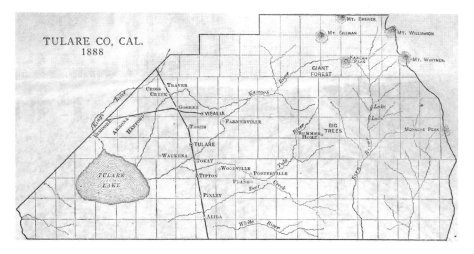

From the Business Directory and Historical and Descriptive Handbook, *published by Pillsbury & Ellsworth, Tulare, California, 1888.*

WILD

TULARE COUNTY

OUTLAWS, ROGUES & REBELS

TERRY L. OMMEN

THE
History
PRESS

Published by The History Press
Charleston, SC 29403
www.historypress.net

Copyright © 2012 by Terry L. Ommen
All rights reserved

First published 2012

Manufactured in the United States

ISBN 978.1.60949.509.1

Library of Congress CIP data applied for.

To the many, with badges and without,
who helped tame this wild land called Tulare...
and to those who still do.

Contents

Foreword

During the decades following the California Gold Rush of 1849, Tulare County was plagued by murders, robberies and thefts. Much of the history of premier train bandits Chris Evans and John Sontag, and later badman Jim McKinney, has survived over the years, but the exploits of others whose deeds were just as notorious have not. *Wild Tulare County* helps to fill that historical void. Terry Ommen has provided a badly needed collection of some of these forgotten men that fortunately has advanced our knowledge of Tulare County history.

Ommen was a peace officer for twenty-five years with the Visalia Police Department, retiring as a captain. His experience coupled with his love of general Tulare County history has served him well. Using this background, he has written history articles for local newspapers and magazines since 1990. His fascination with history extended into membership in the Wild West History Association and the Tulare County Historical Society, for which he served as president and currently serves as an ex-officio member of the board of directors.

His interest in the old-time lawmen and outlaws resulted in this accurate, well-researched and well-written account of some of Tulare County's forgotten toughs who committed crimes not only in Tulare County but also elsewhere. This book contains their stories.

Harold L. Edwards
Bakersfield, California

Harold L. Edwards is a western writer and past president of National Outlaw/Lawmen Association (NOLA), now called the Wild West History Association.

Acknowledgements

I am fortunate that so many have given generously of their time and talent to make this a reality, and I am grateful to all. There is one, however, who deserves special thanks, and that is my wife, Laraine. For forty-one years, she has been willing, although sometimes reluctant, to travel uncharted territory with me, and for that I will always be thankful. This project has been one of those journeys. Without her help, this book could not have been possible.

Our daughter, Lyndsay, was a big help and was important to the project. Her keen editing eye and skill in repairing old photographs contributed greatly. Sharon Doughty came through again, giving freely of her editing time and improving the book considerably in the process. Their hard work and tremendous talent is greatly appreciated.

A number of people gave valuable research assistance, including Peggy Perazzo, who provided important Ruggles brothers material; Marian Shippey Cote, who did amazing genealogy research and diligent detective work; and Sophie Britten, who supplied difficult to find Lovern history. To all, I am most appreciative.

Thanks and appreciation also go out to the staff and volunteers of the Tulare County Library. Head reference librarian Mike Drake and reference librarians Rodney Soares and Carol Beers were all helpful in providing reference and technical assistance. Sheryll Strachan, volunteer coordinator and my boss as a library volunteer, was always helpful and patient with my less than predictable work schedule. Dorothy Neeley and Marge Robinson, fellow volunteers in the Annie R. Mitchell History Room, tolerated my sporadic work schedule and picked up the slack while I was away.

ACKNOWLEDGEMENTS

Tulare County Museum curator Amy King deserves thanks for providing materials and photographs from the museum archives. In addition, the staff members at the Visalia Cemetery were also helpful providing valuable historical assistance. I owe Dona Shores, Cheryl Avila, Maria Resendiz and Ronnie Greenlee big thank-yous.

For the past year, I have worked with Commissioning Editor Aubrie Koenig and, more recently, Project Editor Ryan Finn of The History Press. Their assistance and professionalism have made this a smooth process.

Finally, I want to thank historians Bill Allen, John Boessenecker, Jeff Edwards, Lee Edwards, Dallas Pattee, Bill Secrest Sr. and so many others, including Annie R. Mitchell and Joe Doctor, both deceased, who worked so hard uncovering and writing about Tulare County history. All have been inspirational and motivated me to do my part.

Introduction

Violent men have been a part of Tulare County since its beginning. On July 10, 1852, the newly created county held its first election, and the following month, Judge Walter Harvey shot and killed Major James D. Savage, the former commander of the famous Mariposa Battalion. A few months later, John Ball killed newly elected auditor and recorder Dr. C.E. Everett over a card game.

Although many law-abiding people called Tulare County home, the beautiful yet hostile land seemed to have a disproportionately large number of lawless men living within its borders. It is not clear why. Originally, the expansive boundaries of Tulare County stretched from Mariposa County in the north to Los Angeles County in the south, the Coast Range in the west and to the Utah Territory (now the Nevada state line) in the east. Maybe badmen were drawn to this wild land because it afforded them many places to hide in the swamps, deserts, mountains and small, remote settlements. Or perhaps the wild country, with its searing heat, alkali dust and tule fog, just caused good men to turn bad.

Regardless, the ruffians brought banditry, murder and unspeakable evil, all of which made Tulare County and its environs a dangerous place. Naturally, violence frustrated both residents and the local press. One county newspaper lamented that Tulare County had an unenviable reputation as the "resort of train robbers and desperate characters." Another complained about how little regard there was for human life and thankfully but sarcastically reported, "No murder this week."

The lineup of badmen chronicled here is certainly not complete. It does, however, offer a sample of the tough characters who did their part to give

Tulare County a rough-and-tumble reputation. Each lived in this place for a time, yet most did not feel constrained by its boundaries, and forays across the county line were common. *Wild Tulare County* provides a glimpse of history that is not often talked about—one that played a part in creating the Wild West. It's raw, it's wild and it's true.

Charles Reavis

A Hard Character

Although love brought Charles Reavis to Tulare County, his short stay was anything but a love story. He had a violent streak, and in 1889, the county experienced this cold-blooded killer at his worst.

Tough guy Reavis hailed from Missouri and, proud of his reputation, once boasted that he shot a man seven times before slashing him with a razor.[1] In about 1887 while in Missouri, he married fourteen-year-old Annie Yarnell. But after just three days of marriage, the young bride felt so abused by her thirty-eight-year-old husband that she left him and returned to her parents. In November 1887, Annie and her family left Missouri and settled in Tulare County near Cottage, a little community about twelve miles east of Visalia. A year later, Reavis made his way to Tulare County, obviously following his young wife. Somehow he convinced her to live with him again, and after just one day, the abuse continued. So, like before, she returned to her parents.[2]

Reavis continued to pursue and harass Annie, and finally she had enough. On the morning of July 5, 1889, she went to Visalia to meet with District Attorney W.R. Jacobs. At that time, she swore out a complaint against her husband, charging him with disturbing the peace and using vulgar, profane and abusive language toward her. Jacobs issued an arrest warrant for Reavis that was given to Deputy Sheriff John "Nick" Wren for service. Although Wren apparently had no prior law enforcement experience, recently elected sheriff Daniel G. Overall appointed him to be his deputy.

Wren was born in Illinois in 1849 and came to California in 1863. He lived in San Francisco for a time, working various jobs. In 1871, he

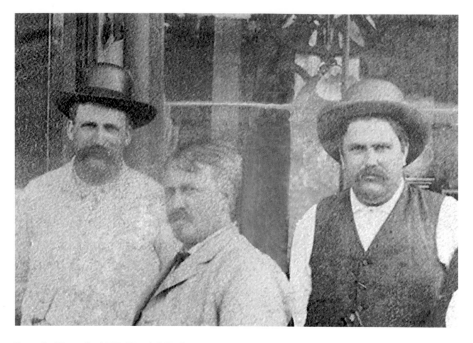

Born in Texas in 1857, Daniel G. Overall came to Visalia in 1859. As a well-respected and public-spirited businessman, he was elected Tulare County auditor, and without previous law enforcement experience, he was elected Tulare County sheriff, serving in that capacity in 1889 and 1890. *Left to right*: Dan Overall, L.V. Nanscawen and Wheaton Gray, image circa 1885. *Author's collection.*

was employed at Roessler & Harwood as a broom maker and earned a reputation as one of the best at his craft on the West Coast.[3]

In about 1874, Wren arrived in Visalia and labored at various jobs in the county. He worked as a teamster in the Sierra Nevada range and as a saloonkeeper. He married Amanda in June 1877, and by 1879, he had purchased the Visalia House Saloon. Later, he took over the operation of the entire Visalia House, a well-known lodging establishment. In 1882, he purchased an interest in the Schlah and Henke Saloon in Fresno.[4] Wren liked being a businessman, and while operating his saloons, he also became part owner of the McKinley & Company livery stable in Visalia.

On Friday afternoon, July 5, 1889, with the Reavis warrant in hand, this businessman turned lawman left for Cottage. Upon arrival, Wren heard that the wanted man was in Visalia, so the deputy began his trip back to town. Near R.H. Arnett's house, he met Reavis's wife, Annie, who was in a wagon driven by Charles Kirkman. As the three were talking, a single rider approached, and Annie yelled, "There's Charlie now!" As Reavis got closer,

the deputy climbed down from his buggy and stood on the roadway, holding his pistol in his hand behind his back. Both Annie and Kirkman ran for cover. As the two men met, the deputy said, "I want you," to which Reavis replied, "You do, do you?"[5] Reavis pointed his revolver at the deputy, and sensing immediate danger, Wren quickly aimed his pistol at the wanted man and fired. His shot missed the target and hit Reavis's horse instead. Reavis immediately returned fire, hitting Wren in the head with a single deadly shot. Mortally wounded, the lawman staggered and collapsed on the road.

After the shooting, Reavis walked over to Wren's lifeless body and took the deputy's pistol, his silver watch and other personal items. He ordered the unarmed Kirkman back into his wagon and found his wife hiding in a nearby barn. Under threat of death, Reavis escorted her back to Kirkman's wagon. Reavis mounted his wounded horse and followed behind the wagon as the three headed east toward Cottage. After a short distance, Reavis's horse gave out, and the killer climbed aboard the wagon with the other two. As he joined them, he proudly held two pistols in the air and bragged about his bravery "in taking off the sheriff."[6] As they approached Annie's house, her folks were out front. Reavis told them what he had done and quickly left the area. Kirkman went home, and Annie remained with her parents.

When word of the shooting reached the authorities, a posse was formed, led by Deputy Sheriff Harrison White, a decorated Civil War veteran. His group came close to capturing the killer, but under the cover of darkness, Reavis was able to hide in the thick brush and escaped into the nearby swamp. The morning after the shooting, Reavis made his way back to Visalia and into Spanishtown, a tough area of the town. He had a meal that he paid for with property stolen from Wren, and he later visited a house of ill repute.

At dusk on Sunday evening, July 7, Reavis appeared at John A. Patterson's ranch two miles north of Visalia. Patterson, a former California state assemblyman representing Tulare County, was a big landowner. Reavis asked for something to eat, and Patterson went to the kitchen to accommodate the stranger. While there, one of his ranch hands, Willis L. Pratt Jr., quietly informed his boss that the stranger was Reavis, the killer of Deputy Wren.

Patterson quietly asked Pratt to quickly saddle a horse, ride into Visalia and notify the sheriff while he stalled the killer. Patterson had his cook prepare a meal for the man. When finished, Reavis relaxed on the porch with Patterson, unaware that the posse was coming to capture him. At one point, he boldly asked his host if he had heard anything about the killing of the deputy. Patterson, not sure how to answer the question, gave a vague response. Occasionally, there were lulls in the conversation, but Patterson did

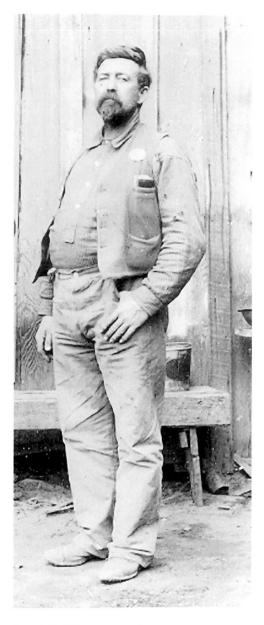

Sam L.N. Ellis was part of the posse hunting Reavis. When the wanted man was cornered on the Patterson Ranch in 1889, Ellis shot and killed him with his Winchester rifle. The following year, he was elected Tulare County supervisor and served for several years in that capacity, image circa 1900. *Author's collection.*

what he could to stall his visitor. Finally, Reavis became antsy and said that he was leaving.

As he walked into the yard, he saw buggies approaching, so he quickly leaped over a fence and ran through the field heading west. He spotted a member of the posse in front of him, so he reversed his direction and bolted back toward the Patterson house. As he did, he came face to face with posse member Sam Ellis, who also happened to be deputy Tulare County assessor at the time. Ellis ordered Reavis to stop, but the man refused and kept on coming. More orders were given, but still Reavis continued to advance. When he was within a few yards of Ellis, the gunman raised his pistol, and as he did, Ellis pulled the trigger on his Winchester rifle, striking his attacker.

The mortally wounded man was brought to the Tulare County Jail in Visalia, and an excited crowd gathered to get a glimpse of him. At about 10:00 p.m. that Sunday night, the forty-year-old gunman was dead, "putting an end to the spirited two days pursuit."[7] Sam Ellis was later elected to the Tulare County Board of Supervisors.

Reavis's body was taken to the funeral parlor of Harvey N. Denny and prepared for

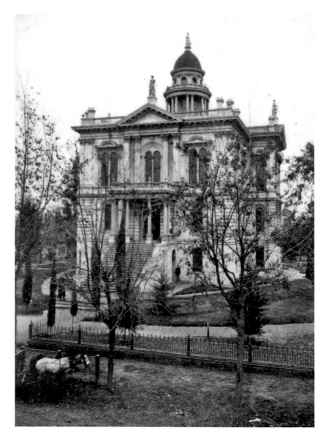

This handsome building was completed in 1877 and housed the Tulare County Courthouse, county offices and the Tulare County Jail. The jail was located in the basement of this building, and it is where Charles Reavis was brought after he was shot. He died here, image circa 1890. *Author's collection.*

viewing. Hundreds came by to see the killer of Deputy Wren, including Annie Reavis.[8] According to some, she cried hysterically when she saw his face—it was not clear whether it was from grief or relief. He was buried in the potter's field section of the Visalia Cemetery.

Deputy Nick Wren, age forty, was laid to rest at the Visalia Cemetery with full honors on July 7, the same day that his killer was slain. He was a respected member of the Ancient Order of United Workmen, Visalia Chapter 79, and had a $3,900 life insurance policy that went to his widow, Amanda, and their three children.[9]

The tragic murder of lawman Wren made news statewide. A San Francisco newspaper called Charles Reavis a "hard character,"[10] and the Sacramento newspaper called the killer "one notorious desperado."[11] Fortunately for the citizens of Tulare County, his stay was a short one thanks to a Winchester rifle and the good aim of Sam Ellis.

The Desperate Life of
Frank Creeks

Franklin "Frank" Creeks was born in Missouri in 1882 to John and Lenora Creeks. Eventually, the family moved west, and by 1900, they were living in Poplar, a small community a few miles west of Porterville. Although not much is known about Frank's early years, his life as a young adult is well documented. Unfortunately for Creeks, it was filled with violence and bloodshed, and it continued until his life ended on the gallows of Folsom Prison.

His life of crime began on February 25, 1902, on the road between Porterville and Plano. James Nelson Cornell, a seventy-four-year-old rancher who lived just south of Porterville, took his horse and buggy for a business trip into town. The well-known and respected man had health problems, so after an extended time had passed and he hadn't returned home, his family became worried. They traced his route, and at about 3:00 p.m., they discovered his lifeless body lying in a thicket of brush along the road about one-fourth of a mile from the house. The family presumed a heart-related cause, so without disturbing the body, they notified the authorities. When officials arrived, the dead man's body was turned over, and "a gush of blood came from the gaping wound" found in his back, the obvious result of a shotgun blast.[12] Robbery was the apparent motive, as his right trouser pocket was turned inside out.

Tulare County coroner Thomas C. Carruthers took charge of the body, and the murder investigation quickly focused on a young man who had been seen near Cornell's property earlier that day. Tulare County sheriff's officials distributed the suspect's description to neighboring jurisdictions, and at about 10:00 the evening of the shooting, Visalia night watchman William DeVall spotted a man fitting the description. He had a boyish face

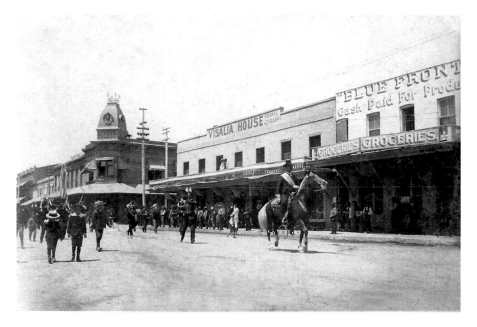

After Frank Creeks killed James Cornell along the road near Porterville, he fled to Visalia. He was arrested near the Visalia House, a hotel (including a saloon) built in 1859. It was located at Main and Church Streets, image circa 1895. *Author's collection.*

and nervously moved around town. As the lawman approached him in front of the Visalia House, the young man became even more anxious. Sensing that he had his man, DeVall placed him under arrest and booked Frank Creeks into the Tulare County Jail. At the time of the arrest, the suspect had in his possession thirty dollars in cash and a revolver with a box of cartridges.

While the young man was in custody, the authorities began building their case against him. They learned that shortly before the murder, he had borrowed a twelve-gauge single-barreled shotgun, and soon after the shooting, he returned it to the owner. He then changed his clothing, purchased a revolver and bullets in Porterville and took the evening train to Visalia.

A coroner's inquest was conducted, and the inquest jury, led by foreman Thomas E. Henderson, a former Tulare County supervisor, concluded that "[Cornell] came to his death on the 25th day of February, 1902, in this county, by a gunshot wound in the back and the jury further finds that the said gunshot wound was inflicted by one Frank Creeks. And we charge the said Frank Creeks, with willful, deliberate and premeditated murder."[13]

The murder trial began on April 15, 1902, in the courtroom of William B. Wallace, judge of the Tulare County Superior Court. District Attorney Jonas

Tulare County district attorney Jonas A. Allen prosecuted Frank Creeks in his murder case. Allen served as DA for four years. When he left office, he went into private practice until May 1911, when he was appointed Tulare County Superior Court judge by California governor Hiram W. Johnson. He served as judge until January 1937, image circa 1911. *David Allen Collection, retired Tulare County Superior Court judge.*

A. Allen and his deputy George G. Murry prosecuted the case, and D.M. Edwards and James S. Clack made up the defense team. As the prosecutors laid out their circumstantial evidence case, public opinion was clearly on their side. Alonzo Melville Doty, the local newspaper publisher, reported that "nine-hundred and ninety-nine out of a thousand believe he [Creeks] is the murderer."[14] For the next two weeks, the trial involving "one of the most atrocious murders ever committed in Tulare County" captured the attention of the public, and every day the courtroom was packed.

On May 3, the closing arguments were presented. At 1:00 p.m., the members of the jury were given the case, and by 2:00 p.m., they had reached a verdict. Judge Wallace ordered Creeks back into the courtroom, where the accused took his chair between his mother and his attorney. When M.W. Smith, the jury foreman, was asked if a verdict had been reached, he responded that it had and said, "We the jury, find the defendant guilty of murder in the first degree."[15] Upon hearing the words, Creeks broke down and wept, showing his first sign of weakness since the beginning of

William B. Wallace was born on a wagon train near Platte City, Missouri. His family traveled west to California and came to Tulare County in the early 1870s. He studied law, became a justice of the peace and was elected Tulare County district attorney. He became a Tulare County Superior Court judge in November 1898, serving until 1926, image circa 1915. *Author's collection.*

the trial. The defense argued that some evidence presented in the case was questionable and requested a new trial. The judge denied the request.

On May 28, the convicted man stood before the judge for sentencing and learned his fate—death by hanging at San Quentin State Prison. Creeks was turned over to Tulare County deputy sheriff John Hazen for his return to the county jail. The authorities moved quickly, and the following morning, Deputy Hazen and his prisoner boarded the train for their trip north to San Quentin.

Creeks's attorneys continued to challenge the conduct of the trial, with their challenge eventually reaching the California Supreme Court. The appeal was heard in January 1904, and the high court agreed with the defense. A new trial was ordered.

Tulare County sheriff William Collins took the train to San Quentin to bring Creeks back to Visalia for his new trial. On February 13, 1904, the two boarded the Southern Pacific train for Tulare County. They talked cordially as they shared a bench seat. As the train passed Oakland, the sheriff felt comfortable with the prisoner and trustingly removed his handcuffs. Near

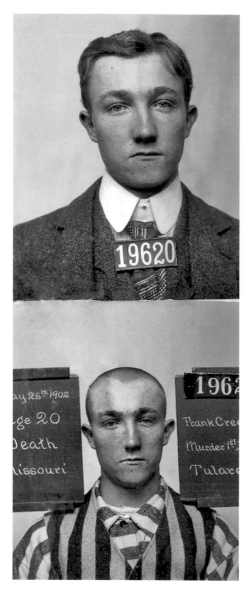

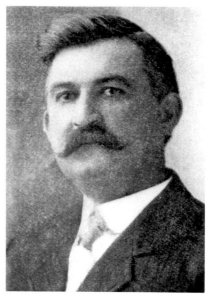

Above: William W. Collins, shown here in 1914, was born in Ohio in 1865 and came to California as a young boy. He lived in Kern County, Inyo County, and in 1889, he moved to Tulare County, settling in the city of Tulare. Elected sheriff in 1902, he served for three terms. A popular lawman, Collins was known for getting prisoner confessions, thereby avoiding trials and saving taxpayer money. *Author's collection.*

Left: Frank Creeks entered San Quentin State Prison on May 28, 1902, becoming convict no. 19620, sentenced to death for first-degree murder. He was photographed in civilian attire as he entered prison and then again after he was given his issued prison-stripe uniform. *California State Archives, Sacramento.*

Los Banos, shortly after 2:00 p.m. the sheriff got up from his seat to get a drink of water. While the lawman's back was turned, Creeks made a daring lunge headfirst through an open window of the car.[16] A passenger quickly alerted the sheriff, who frantically ran from car to car trying to find someone who could signal the engineer to stop the train. Having no luck, he finally ran to the back platform of the train and pulled the emergency cord.

As the train slowed, Sheriff Collins jumped off and ran after Creeks. When the sheriff was about half a mile from Creeks, he fired his revolver at the man but missed. Luckily, the gunfire attracted the attention of a nearby man with a horse and buggy. The sheriff commandeered the vehicle and quickly caught Creeks in the open country. He surrendered, and the sheriff examined him for any sign of injury. Creeks was in good condition, with only minor abrasions, remarkable considering that he had jumped from a train traveling thirty-five miles per hour. The two men reboarded the train, and few words were exchanged on the remainder of the trip.

When Creeks arrived in Visalia, he was stooped over and obviously stiff from his daring train escape. He was escorted off the train and was taken to the Tulare County Jail. County physician Edwin Farrow examined the young man and found him fit. That evening, Creeks asked to speak with a Catholic priest, so Father Patrick Brannon of Visalia's St. Mary's Catholic Church obliged and spent time with him.

The new trial began with Judge Wallace presiding, the same Superior Court judge who tried Creeks in 1902. Evidence was introduced and witnesses testified, but unlike his first trial, Creeks took the stand. He testified that at the time of Cornell's murder, he was hunting and therefore had nothing to do with the crime. After nearly three weeks, the case was turned over to the jury, and on April 16, 1904, it reached a verdict. Flanked by two officers, Creeks was slowly led back into the courtroom. He had a solemn look, as if he anticipated another guilty verdict. Jury foreman Harvey Harrell spoke, "We the jury, find the defendant guilty of murder in the first degree and recommend that he be imprisoned for life."[17] Despite the harsh sentence, the defendant, his parents and his defense team seemed relieved that he did not receive the death penalty.

On April 17, Judge Wallace formally sentenced Creeks to life in Folsom Prison. When Sheriff Collins

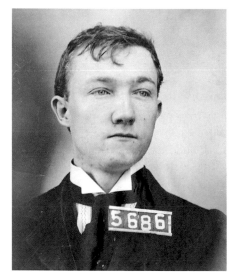

After Frank Creeks was again found guilty of murder in his second trial, he entered Folsom State Prison on May 1, 1904, becoming convict no. 5686. During the next ten years, this young inmate with a boyish face earned a reputation as a tough guy. *California State Archives, Sacramento.*

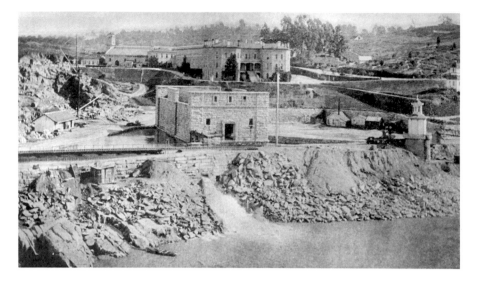

Folsom Prison, shown here in 1903, opened in 1880 on the site of the old Stony Bar Mining Camp on the American River. It housed the prisoners too tough for San Quentin. Built with granite slabs and sheet iron, the cells became ovens in the summer and iceboxes in the winter. *California State Printing Office, Sacramento.*

and his prisoner boarded the Sacramento-bound Santa Fe train, the handcuffed and shackled Creeks was not in the best mood. The two had a quiet ride.

Frank Creeks remained incarcerated at Folsom, and while there he earned a reputation as a "badman"—quite an honor considering he was surrounded by many hardened criminals.[18] In October 1914, while Creeks shared a cell with a man named George Phelps, the two devised an escape plan. A few minutes after 8:00 p.m. on October 16, they put their plan into action. The duo managed to unlock the cell door using a makeshift key they had fashioned from a piece of wire. As Sergeant John Drewry and guard Joe Kerr made their rounds, Creeks and Phelps attacked them with a dumbbell and a knife. In the struggle, the jailors dropped their pistols, and Kerr was able to break free to alert other prison guards. Drewry, however, was killed in the attack. Now armed with pistols, the convicts ran through the prison yard, where other guards were waiting for them. Gunfire was exchanged, and Phelps was killed along with Frank Maher, another prison guard. Somehow Creeks made it out of the prison and hid along the nearby American River.

A Berkeley newspaper covered the escape, calling it "one of the boldest and most desperate yet made at Folsom."[19] Warden John J. Smith predicted a quick capture as he brought out the bloodhounds. At about 9:30 p.m. on October 17, one day after his escape, Creeks was captured in a rooming

house in Loomis, a place he had rented using money he had received from selling Sergeant Drewry's pistol.[20]

Creeks was charged with the murder of Sergeant Drewry. John Creeks, his father, and James Clack, one of his earlier defense attorneys, visited him after his capture. On October 22, Clack announced that he was once again going to represent Creeks. In his trial, Creeks pleaded not guilty to the murder of the prison guard. His attorney argued that Phelps, the deceased cellmate, had killed Drewry rather than Creeks. However, Creeks was found guilty and sentenced to death by hanging. The verdict was appealed to the California Supreme Court, which affirmed the conviction, saying that even though Creeks may not have personally killed Drewry, "each [accomplice] is responsible for everything done by his confederates."[21]

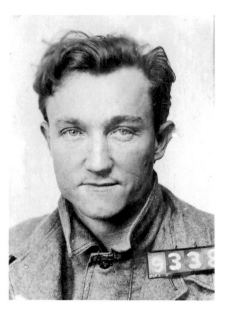

After Creeks was convicted of killing guard John Drewry in a prison escape, he reentered Folsom as convict no. 9338 on January 2, 1915. His young, boyish look was gone as he awaited his fate on the gallows. *California State Archives, Sacramento.*

On April 7, 1915, Creeks, along with two other prisoners, attempted another escape. This time, the break was foiled within the walls of Folsom Prison, and from that time on, Creeks was kept under constant watch. For the next several months, appeals were made for a new trial, and there was a request for a stay of execution to Governor Johnson. Creeks's father even attempted to get the state legislature to ban the death penalty in California.

However, none of these efforts stopped the inevitable. On August 26, 1915, Creeks met with a priest and listened intently to the consoling words from the man of the cloth. Just before 10:00 a.m. on Friday, August 27, 1915, the thirty-three-year-old man was escorted to the gallows room. His face was pale, and his balance was unsteady as he nervously stood on the trapdoor. At 10:00 a.m., the door was sprung, and Creeks dropped as seventy-five people in attendance witnessed his last breath.[22]

The brief and violent life of this young man was unfortunate and regrettable. But his actions leave little doubt that he was one of Tulare County's notorious badmen.

Jim McCrory

Hung by the Neck by a Mob, Justly Deserved

James G. McCrory was a decent man when sober, but when drunk he became "one of the most fiendish devils in human shape that ever disgraced the earth."[23] Much of his early life is a mystery, and so are the circumstances that brought him to Visalia, the county seat of Tulare County.

He was born in Arkansas in about 1836, and by age twenty, he was in Mariposa County. He married Julia Ann Bozeman, a girl about five years his junior, and eventually the couple moved to Visalia. By April 1867, McCrory was the proprietor of Visalia's El Dorado Saloon, located on Main near Church Street. In one of his first advertisements, he called his saloon a "new and elegant establishment" and promised that he would "always be on hand to serve to his customers the very best wines and cigars."[24]

McCrory had a pleasant disposition and was active in civic affairs. He ran the El Dorado for a few years and operated a popular Visalia horse racing track at the same time. He was a lawman for a time, serving as deputy Visalia marshal, and even considered running for Visalia marshal but withdrew his bid before election day. He also ran for Tulare County sheriff but lost to Alpha H. Glasscock. He supported Father Daniel Dade's Catholic church and was appointed volunteer fireman, a position with considerable prestige. From all appearances, he was a responsible, civic-minded man. McCrory wasn't a big man, although at almost five-foot-ten he was taller than most men of the day. He had a slim build, with a light complexion, gray eyes and light-colored hair, and he had what was described as a high forehead.[25]

Even though he was likeable, it didn't take long for Visalians to discover that he had a mean and ruthless side. One of his first violent confrontations

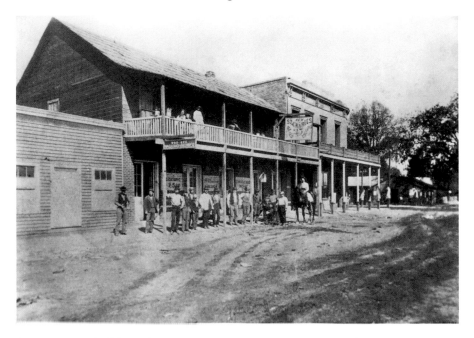

The St. Charles building, with its lodging house and saloon, was one of several in Visalia offering the liquid refreshment so much in demand. The St. Charles was located on Court Street near Main, image circa 1881. *Annie R. Mitchell History Room, Tulare County Library, Visalia, California.*

came while he was serving as deputy marshal under Marshal John W. Williams. On Tuesday, December 1, 1868, a miner and mountain man by the name of John Schipe came to Visalia for one of his regular rest and relaxation visits, during which he would partake of liquid refreshment. Known for his heavy drinking, he began making the rounds at the various saloons. By evening, he was intoxicated and belligerent, staggering around the streets of Visalia. When Marshal Williams confronted Schipe, asking him to calm down, the drunken man resisted and threatened the marshal. Deputy Marshal McCrory was called in to assist, and during the struggle to arrest Schipe, the suspect was hit with "three pistol balls" to the body, one entering his left eye and exiting out the back of his head. The fatal gunshots were credited to Williams and McCrory, according to the coroner.

The *Tulare Times* called the shooting "regrettable," and Schipe's friends called the deceased a "good, kind-hearted, quiet and peaceable man when not under the influence of liquor."[26] The two lawmen were cleared of any wrongdoing by acting Tulare County coroner Arthur Shearer.

Some in the community, however, questioned the actions of the lawmen. About three weeks after the Schipe killing, a man named Samuel Hall and his friends were drinking at the El Dorado, where McCrory was tending bar. Hall and his friends exchanged words with McCrory about the Schipe incident, and it quickly escalated to a physical altercation between Hall and McCrory. McCrory drew his pistol and fired at Hall, hitting him three times, once in the right arm, another in his shoulder and the third grazing his head. Hall survived.[27]

Reportedly, sometime in 1869, McCrory arrested a man named Morano. At the time, the man had hard feelings over the arrest and threatened to kill McCrory. He took no action against McCrory until Saturday evening, March 26, 1870. The two men engaged each other in Visalia, and in the altercation, Morano was shot several times. McCrory was arrested for attempted murder and posted bail. On April 1, McCrory appeared in Justice of the Peace Nathaniel O. Bradley's court for a hearing, but the proceedings were not recorded. The local newspaper simply reported that "McCrory was cleared" of all charges.[28]

On October 21, 1870, James McCrory had yet another gunfight, this time with Manuel Berelos (sometimes spelled as Beralas), the bartender at Visalia's Fashion Saloon. The exact reason for the conflict is unclear; however, McCrory later claimed that the man had threatened his life. Regardless, hostile words were exchanged between the two men. McCrory left the saloon, returning shortly with a double-barreled shotgun. As he reentered the saloon, he saw Berelos with his back to him. He put the shotgun to his shoulder and fired, "blowing nearly half his head off."[29] After the brutal killing, according to witness William Harp, McCrory said to those standing nearby, "B- G--, I got my Ingen, boys; there he lays."

McCrory pleaded not guilty, and his first-degree murder trial was set for February 20, 1871, in District Judge A.C. Bradford's courtroom. Probably as part of a plea bargain, on February 23 McCrory withdrew his not guilty plea and pleaded guilty to second-degree murder. His plea was accepted, and he was sentenced to fifteen years in the state penitentiary. Many were grateful that the violent McCrory was finally going to prison for his actions.

While McCrory was in San Quentin State Prison, his defense lawyer appealed the case, claiming improper actions by the court, even though McCrory had pleaded guilty to the murder. On October 19, 1871, the California Supreme Court ordered a new trial, which was set for January 2, 1872. The second trial resulted in a not guilty verdict, and McCrory went free. The community was not happy with the outcome. How could this man

who had so often shown his deadly and vicious nature go free? McCrory sensed the community's displeasure and left town. The rumor was that he had gone to the Arizona Territory, where he got "into a shooting scrape… killed a soldier and had to leave."[30]

But McCrory was not finished with Visalia yet. At 6:00 a.m. on December 24, 1872, McCrory, after being gone from Visalia for several months, returned on the Goshen stage. As he wandered around the town he knew so well, he made it known that he had come back to get even and planned to "kill my man before night," but he did not identify his target. He went to the old El Dorado Saloon, now owned by Charles Allen, and asked him for money to buy a pair of pants. Allen gave him ten dollars. With money in hand, McCrory left the saloon and circulated around town, drinking heavily. Highly intoxicated, McCrory returned to the El Dorado at about 5:00 p.m. He was belligerent, angrily waving his pistol and threatening to shoot someone.

The commotion got the attention of Allen in the back of the saloon. He came out and told McCrory, "Jim, don't act so childish, put up your pistol and be a man." McCrory angrily responded, "I might as well kill you as any other son of a b----," and then shot Allen in the stomach. Seriously wounded, Allen pleaded with him, "For God's sake Jim, don't kill me. I'm unarmed."[31] McCrory advanced on his victim, shooting him two more times. As Allen slumped to the floor, McCrory walked up to him, placed his pistol barrel against the dying man's forehead and fired again. McCrory then pointed his pistol at the bartender, Cordova, and pulled the trigger, but his pistol misfired. McCrory ran from the saloon and hid in an outhouse in back.

A short time later, Deputy Sheriff Jesse Reynolds, District Attorney Allen J. Atwell and Marshal Joseph Myers arrived and confronted McCrory. The killer yelled threats at the lawmen through the outhouse door, vowing to kill anyone who tried to arrest him. When the lawmen forced their way into the structure, he was wildly waving a pistol in each hand. They disarmed him and took him to the Tulare County Jail.

Word spread quickly about McCrory's violent return to Visalia, and the citizens were angry. By the time the lawmen arrived at the jail with their prisoner, an agitated crowd had already gathered and was heard chanting, "Hang him." Some tried to forcibly take McCrory from the officers, but the lawmen were able to resist and got their prisoner into a jail cell. Sheriff Glasscock asked for calm from the group of about two hundred. His pleas were ignored, and the group, now an angry mob, demanded that the sheriff turn over the prisoner. The lawman refused and added additional guards at the jail.

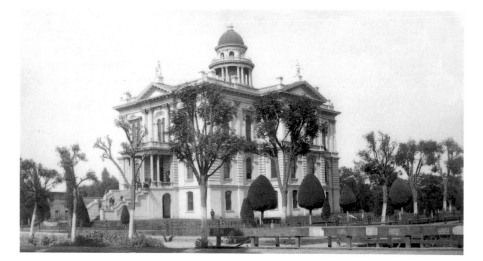

Mill Creek flows through Visalia, and in the early years, much of the creek channel was open, requiring bridges for crossing. This wooden bridge, with the railing in the foreground, was on Court Street and spanned the creek in a north/south direction at Center Street. The Tulare County Courthouse in Courthouse Square can be seen in the background. It was at an earlier bridge on this site in 1872 that vigilantes hanged James McCrory. After that, the Court Street Bridge became known as McCrory Bridge, image circa 1895. *Author's collection.*

The call for the prisoner became louder, though, and the mob proved to be too much for the authorities. The people battered through the jail door using a metal pipe and crowbars and found McCrory cowering in his cell, paralyzed with fear. He refused to stand or speak, so the vigilantes placed a rope around his neck and pulled him out. They dragged him to the Court Street Bridge, tied the other end of the rope to the bridge railing and threw him over the side. McCrory's body was intentionally left hanging over Mill Creek for several hours to serve as a sobering warning to the rough element in town. A collection was taken from the vigilantes for the twenty-dollar burial cost so that the county would not incur any additional expense because of the desperado. He was buried in an unmarked grave at Visalia Cemetery. The news of McCrory's hanging was widely covered.

The *Tulare Times* reported, "We say 'well done' to our citizens who executed this devil incarnate."[32] The *Sacramento Bee* commented:

> *Noble Visalians, you have returned to the practice of the primitive days of '49, when if a man murdered another he was hanged, in the maintenance of justice if not in maintenance of law; for then the people could not see*

38

1869

J G McCrory

Aug 4	dues for July	50
Sept 8	" " Aug	50
Oct 6	" " Sept	50
" "	Shirt & Belt	6 00
Nov 3	dues for Oct	50
Dec 1	" " Nov	50
Jany 5	" " Dec	50
Feb 2	" " Jany	50
Mar 2	" " Feby	50

Expeled by unanimous vote of the Co
Feby 2d 1870

Hung By the Neck Dec 24 1872 By a Mob Justly Deserved

At one time, James McCrory was considered an upstanding citizen of Visalia and was allowed to become a dues-paying volunteer fireman. However, as the fire department's secretary's ledger book shows, he was expelled by a unanimous vote of the company in February 1870. After McCrory's hanging, the department secretary noted on McCrory's ledger page a fitting end to the badman's life. In his bold, fancy cursive hand, the secretary wrote, "Hung by the Neck, December 24, 1872, By a Mob—Justly Deserved." *Visalia Fire Department.*

and did not see why these two principles of society should be divorced. You hanged a man because he had murdered another, and did not wait for Court or Jury to tell when and how not to do it. And by so doing you have carried more terror to the hearts of scoundrels than could a score of judicial executions. You had of course, an extraordinary case to work upon, or you would not have swerved from the modern beaten track, but in such case a

temporary return to the days of '49 does a power of good sometimes. It will keep your atmosphere comparatively clear for years to come.[33]

Locally, the hanging created a call to action. On January 1, 1873, several prominent citizens of Tulare County wrote an open letter, part of which read:

Whereas the taking of the life of our fellow men, and the attempt thereof, upon trifling pretexts, has become of frequent occurrence in our midst, and whereas crime seems to be upon the increase, and criminals to receive no adequate punishment therefor:

Now we, the citizens of Tulare County resolve ourselves into a Committee of Public Safety, and we solemnly bind ourselves together and agree to aid each other in the maintenance of public peace and order, and in the full and just execution of the laws, upon every violation thereof, without fear or favor; and we further hereby covenant and agree with each other, that we will personally and together, exert ourselves in every proper way, to the end that no criminal in Tulare County shall hereafter escape the punishment due to his crime.[34]

James McCrory suffered the wrath of an angry mob on Christmas Eve 1872 and paid the ultimate price for his wicked ways. For many years, the name McCrory, "the worst man that has ever made Visalia his home,"[35] served as a warning that ruthlessness would be dealt with swiftly and surely. For years after the hanging, the bridge where he breathed his last was known as McCrory Bridge.

Ruggles Brothers

Two Bad Tulare County Boys

L yman and Martha Ruggles were financially secure and well respected, so by almost all measures their two sons, John and Charles, should have looked forward to a bright future. But something went terribly wrong for the two Ruggles boys, and their lives ended tragically—dangling side by side from vigilante ropes.

In 1850, Lyman Ruggles came to California from Michigan to try his hand at mining in El Dorado and Nevada Counties. Having little success, he moved to Yolo County near Woodland and began farming. In 1857, he married Martha Ann Dexter, and from that union two sons were born—John in about 1860 and Charles about ten years later. The Ruggles eventually sold their farm and bought a lumber business and later a drugstore. Lyman was an ambitious man who was elected supervisor on the Yolo County Board of Supervisors, and he even ran for the California State Assembly.

By 1875, the family had moved south and purchased 160 acres of Tulare County farmland between Hanford and Traver. Eventually, they purchased additional land near Dinuba.[36] The patriarch of the family did not waste any time establishing himself as a leader in his new community, and by 1877, he had been named a director in the Upper Kings River Canal and Irrigation Company.[37]

Presumably, John accompanied the family to Tulare County. However, in 1878, John appeared in Stockton, California, under the care of Dr. E.A. Stockton for treatment of an undisclosed ailment.[38] On October 31, 1878, while in San Joaquin County, he got into a shooting scrape that almost

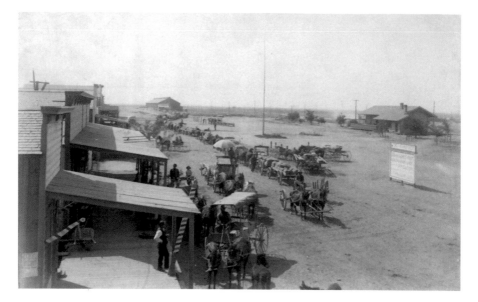

Traver was a railroad town known as a hub for grain shipping. The Ruggles family would have been frequent visitors. Despite its strong agricultural connection, the town was also known for being wild and lawless, image circa 1890. *Annie R. Mitchell History Room, Tulare County Library, Visalia, California.*

proved fatal: "About eight-o'clock last evening a young man named Arthur Avey was walking in the company with a young lady…when a footpad [John Ruggles] stepped out…and demanded their money at the mouth of a cocked revolver. Avey coolly told him that they had no money, but to appease him the young lady took off her ring and gave it to him."[39]

As the young couple ran from the robber, Ruggles fired his revolver at them, missing. Avey returned fire, hitting Ruggles in the back. The couple reported the incident to the authorities while the badly wounded Ruggles turned himself in. He confessed to the crime and also to another robbery a few days earlier.[40] Police called for Dr. Stockton to treat the wounded robber, and the doctor immediately recognized him as his former patient. The bullet had penetrated both lungs, and the doctor gave him little chance of survival. Dr. Stockton was surprised by the robbery committed by Ruggles, calling him the "last person in the world" he would have suspected of committing such a crime. Others were not surprised. A Yolo County newspaper commented on the young man's past, reporting that he "had fallen into the habit of drinking and various confidence games until it finally culminated in the robbery…this is the end of another victim of King Alcohol."[41]

On November 8, 1878, the news of the robbery reached Tulare County, and the local Visalia newspaper provided additional information about the young Tulare County man:

> *A gentleman who has long been intimate with the Ruggles family stated in our office a few days since that the young man who has thus been brought to grief through his own folly, has appeared at times of unsound mind—in fact insane. He has from time to time caused great mental suffering to his parents by his disposition to appropriate other's property—property he could not get from his own family to satisfy this mania. He is said to have an inordinate desire for novels of the blood and thunder order. It is to be hoped that his last experience may have the effect to show him the fatal error of his course. At last accounts, his case was more hopeful and it was thought he would recover. His parents went to Stockton upon hearing the sad news and they have the sympathy of the community in their distress.[42]*

Amazingly, Ruggles survived his nearly fatal gunshot, and on Friday, November 15, he stood before San Joaquin County judge W.S. Buckley. He pleaded guilty to robbery and assault with intent to commit robbery and was sentenced to seven years in state prison. The following day, he became the newest inmate at San Quentin State Prison.

Almost immediately, Ruggles's parents worked to get a pardon from the governor. Letters came in from prison guards, lawyers, lawmen and Dr. Stockton, all asking for leniency. Dr. Stockton wrote that the convicted man was "under my medical treatment for some months before the unfortunate occurrence, for self abuse…a practice which he had been addicted to for two or more years enfeebling his mind and at times rendering him imbecile or so weak-minded as hardly responsible for his actions. I am fully satisfied his unfortunate habits of self abuse was the cause of all his shortcomings."[43]

Judge Buckley even sent a letter on January 22, 1880. Remorseful over the sentence he had given Ruggles, he appealed to the governor, "If you see fit to give him the benefit of such doubt by pardoning him, you would perhaps be doing an act of justice and would relieve my mind in regard to the matter."[44] But perhaps the most persuasive letter came from Ruggles's own mother. On February 14, 1880, she wrote in part, "God in his mercy has said forgive until 70 times 7, and man are not willing to forgive this boy…once. Oh it is too cruel."[45]

The letter-writing effort paid off, and on February 25, 1880, John Ruggles was pardoned by Governor George Perkins, having served less than two years of the seven-year sentence. The free man made his way back to his

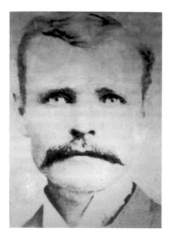

John Ruggles had a bright future, but for some reason, his life went horribly wrong. Were his criminal deeds the result of an evil mind, or were they a sign of a man with a serious mental illness? The people of Redding made up their minds, and John and his brother, Charles, found out quickly how they felt, image circa 1892. *Tulare County Museum.*

family in Tulare County. For the next few years, his life seemed to get better. He purchased farmland in 1886, the same year he married Ida May Henderson. The following year, their daughter, Estella, was born. But in 1889, he had a setback when his wife died, and Estella was placed with relatives in Fresno. Ruggles lost interest in farming, and in 1890, he and his younger brother, Charles, left Tulare County for Northern California.[46] By May 1892, the brothers were living in Shasta County, a place where the Ruggles name would long be remembered.

At 6:00 p.m. on May 14, as the Redding & Shasta stage was slowly making its way up a long grade, John and Charles Ruggles appeared from the bushes beside the road. Both were armed and wore masks. Veteran stage driver John Henry Boyce was driving the four-horse team, and a passenger named Suhr was seated next to him. Amos "Buck" Montgomery, an armed Wells, Fargo guard, was also on board and seated inside the coach.

The Tulare County gunmen signaled for the stage to stop and ordered Boyce to throw down the two treasure boxes, reportedly containing more than $10,000 in gold coins.[47] As the boxes hit the ground, Montgomery fired his shotgun at the bandits. Charles was peppered with pellets, but John and Charles both returned fire, hitting the Wells, Fargo man in the stomach. During the exchange, stage driver Boyce was hit in the leg with a dozen or so pellets, and Suhr was also wounded. The spooked horses bolted, and Boyce was unable to control the stage. Suhr, who was not seriously hurt, took over and drove the stage to Redding. That evening, Montgomery died from his wounds.

At about 2:00 p.m. the following day, three young men who were walking near the holdup scene spotted the wounded Charles Ruggles. They took him to Redding and turned him over to the authorities. Under questioning, he admitted being one of the stage robbers but was vague and deceptive about his partner. Wells, Fargo detectives James Hume and John Thacker began working the case, and their investigation revealed the second robber to be John Ruggles.

Charles's wounds were serious, and his survival was in question. The shotgun blast had done significant damage, with pellets traveling through his chest, nose, arms and hand. One went through his nose and knocked out several teeth, and three penetrated the left side of his chest. Other pellets went into his arms and hand.[48] The detectives wired Charles's father, explaining his condition, and the local Visalia newspaper reported the dire news:

Considerable excitement was caused in Traver yesterday morning on the receipt of a telegram by Mr. L.B. Ruggles announcing that if he wished to see his son Charles L. Ruggles alive to come to Redding at once, as he was mortally wounded in a stage robbery near that place. It was not long after Mr. Ruggles received the dispatch until it was the general topic of conversation on [Traver] streets. The news was a hard blow on Mr. Ruggles and he has the heart-felt sympathy of all who know him, as he is held in high esteem by all. Mr. Ruggles took the noon train for Redding.[49]

Remarkably, Charles survived his injuries, and John continued to evade capture. On May 21, Wells, Fargo distributed a wanted poster for the stage robber and murderer and offered a reward of $1,100 for his arrest and conviction.

The following month, authorities got word that John was hiding in Woodland, California. With the help of relatives living there, Yolo County deputy sheriff Wyckoff, who happened to be John's childhood friend, got a tip. At 9:30 p.m. on Sunday, June 19, John Ruggles entered the Opera Restaurant. While concealing his identity, the deputy followed him and kept him under surveillance. For some reason, John became suspicious and reached for his pistol. The alert deputy drew first and ordered Ruggles to surrender. Ruggles ignored the order, so Wyckoff fired, striking the fugitive in the neck. The wound was not fatal, and Ruggles struggled with the deputy. Soon other officers arrived, and he was restrained.

When searched, John had gold coins from the Shasta stage robbery in his money belt, but the bulk of the loot was not found. Interestingly, he also had a confession letter in his possession with an explanation for his desperate act. In a rambling fashion, he wrote:

First, I suppose, I ought to advance my reasons for starting out on this trip…the ungenerous and spiteful feeling of society towards an ex-con., the lack of chances to marry and settle in life, the quiet persecution of persons

Look Out for Stage Robber and Murderer!

$1100 REWARD

For the Arrest and Conviction of

JOHN D. RUGGLES,

Who was principally concerned in the robbing of the stage near Redding, May 14th, and the murder of Messenger Montgomery.

DESCRIPTION.

He is thirty-two years of age; 5 feet 11½ inches high, weight 175 pounds; born in California; light or florid complexion, long features; heavy, light brown moustache (now colored black), light brown hair, dark blue eyes;

long features, high forehead, square chin; wears number 8 or 9 shoes and 7¼ hat; when last seen wore a black felt hat; has large scar on right side of neck caused by burn; has large brown mole below shoulder-blade; scar on breast-bone; gunshot wound on leg; large, bony hands, calloused from work; restless and uneasy, looking around out of corners of eyes, looking sharply right and left when talking to you; most always has mouth open; smokes cigarettes and makes them; has a habit of clearing his throat every little while, caused by being an inveterate cigarette smoker; does not drink to any extent; folds his arms across his breast when talking to any one, and generally standing or leaning against something; at time of robbery wore a dark coat, spring-bottom bluish pants, with welt-seam along the sides; he carried two 44 cal. Colt bronze pistols.

He was sent to San Quentin November 16th, 1878, from San Joaquin County, for a term of seven years, for robbery, and was pardoned and restored to citizenship February 26th, 1880.

He lived many years with his parents near Woodland, Yolo County. He owns a quarter section of improved land in Tulare County, near Traver, mortgaged to the Sacramento Bank for $4,500, and is well known in that county. For two or three years past has spent considerable time, summers, hunting in Shasta and Siskiyou Counties, and is proficient in the use of all kinds of firearms. He is an extraordinary footman, and can outtravel a horse on mountains; is a thorough mountaineer.

In the robbery, 14th instant, he took from the Express Box 79½ ozs. of quicksilvered gold from Weaverville, about 880 fine, and valued at $1,300; also, 96½ ozs. gold amalgam, about 730 fine, and valued at $1,400; also about $675 in coin. Total, $3,375.

In addition the $600 standing reward offered by the State and Wells, Fargo & Company for the arrest and conviction of this class of offenders, Governor Markham has offered $500. If arrested, wire Sheriff Green, Redding, Shasta County, Cal., or the undersigned. His conviction certain.

J. B. HUME,

J. N. THACKER,

SPECIAL OFFICERS WELLS, FARGO & Co.

SAN FRANCISCO, CAL., May 21, 1892.

After John Ruggles was identified as the second stage robber and killer, Wells, Fargo issued a reward for his capture, describing him as "restless and uneasy" and an extraordinary footman who can out-travel a horse in the mountains. A 1892 poster warned that he carried two .44-caliber Colt bronze pistols. *Tulare County Museum.*

who believed that I was still stealing and who snubbed me and done me dirt. All of which combined to exercise an influence on my mind to lead me into desperate deeds. You all well know how I have worked in days gone by until now. I am a physical wreck. I have a good nerve, but no strength. I have to take medicine all the time or go to bed.

He also had kind words for his brother, writing, "Charley Ruggles was a good boy. Charley Ruggles is a boy easily led…harmless unless aroused and means no harm to a living soul."[50]

John's condition stabilized, and on June 23, he was put in the baggage car of a train heading north. That evening, escorted by Yolo County officers and Detective Thacker, he arrived in Redding, where a large but peaceful crowd had gathered at the station. Ruggles was placed in a wagon and taken to the county jail. When the two brothers met inside the jail, emotions overtook them. John said, "Charley I thought you would die." The two embraced, and after a few minutes, they were placed in separate cells.[51]

While the two were recuperating and awaiting trial, the authorities began hearing talk of lynching but did not take the threat seriously. Their concerns escalated, however, when they heard that angry citizens were meeting secretly to devise a plan to take the brothers out of jail and lynch them.

In the early morning hours of July 24, 1892, forty masked men went to the jail, forced open the door to the locked sheriff's office and demanded the cell keys from the jailor. He told them that the keys were locked in the safe. With a sledge and drills, they forced open the safe, and by 2:00 a.m., the two cell doors had been opened. The boys were led out of the jail and into the street. John knew what the mob was planning and asked for leniency for his brother. Ignoring his plea, the mob marched them to a nearby blacksmith shop, where a crossbeam was found. Ropes were tied around their necks and the other ends to the crossbeam. Their hands and legs were bound.

When a member of the mob asked if they had anything to say, John made a plea for his brother's life and said, "Gentlemen, spare him." They ignored him and further asked John about their involvement in other stage robberies in the area. John said, "I know nothing of these affairs." Then he was asked about the whereabouts of the missing gold from the stage holdup, and again he said, "Spare Charley and I will tell you."[52] The mob was not interested in sparing Charles, so no deal was reached.

The crowd grew impatient, and the order to hang them was given. As the beam was raised, many hands pulled on the ropes, and the two were hoisted into midair. The brothers slowly suffocated as the vigilantes watched

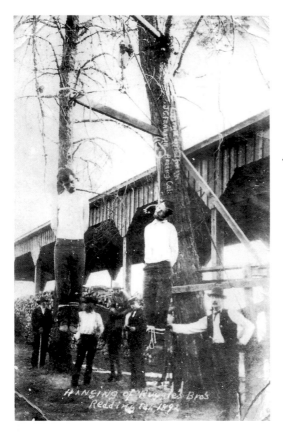

On July 24, 1892, the vigilantes of Redding forcibly took John and Charles Ruggles out of the jail, and without the benefit of trial, the two men were hanged. Their father returned their bodies to Tulare County for burial. *Dallas Pattee Collection, Monson, California.*

and then quietly left the area. The bodies of the brothers were left hanging until about 9:00 a.m., when Shasta County coroner Moody cut them down. An inquest was held and concluded that John Ruggles, about thirty-two years old, and Charles Ruggles, about twenty-two years old, "came to their death…by being taken from the county jail in the City of Redding, State of California, to the place where their bodies were found, and hanged by the neck until they were dead, by parties to us unknown."[53]

The bodies were embalmed, and their father was notified of the deaths. Lyman Ruggles left Traver for Redding on July 25, 1892, to take charge of the bodies. The two boys were returned to Tulare County, and their cremated remains lie at the Smith Mountain Cemetery in Dinuba.

The lynching of these Tulare County brothers made news throughout the state. In Los Angeles, the newspaper pointed out that the hanging was outside the law "but that it will have a discouraging effect on the 'hold-up' industry…it will be perfectly safe to indulge in stage rides in Shasta County no doubt, for some time to come."[54] For years, the lure of the missing robbery loot drew treasure hunters to Shasta County. Some claim that it was found, but others believe that the Ruggles gold is still out there, waiting to be discovered.

Josiah Lovern

A Visalia Ruffian

Josiah "Si" Lovern was born to John and Lucinda Lovern in Iowa on April 28, 1852. He was one of seven brothers, and there were three sisters in the family. The record seems to show that he arrived alone in California in about 1864.[55] According to his own statement, he came to Tulare County in about 1887[56] and eventually made his way to Visalia, a place where he would earn the unenviable reputation as being one of the town's most notorious characters.

Lovern (sometimes spelled as Lovren or Loverin) began attracting community attention when he registered to compete as a sulky race driver in a special horse race in the 1891 Tulare/Kern District Fair held in Visalia. By the following year, he was a saloonkeeper in town, and it was then that his unsavory reputation began to form.

Lovern's Saloon, located at Main and Garden Streets in Visalia, attracted undesirables from the beginning. On Friday night, November 11, 1892, local gambler and troublemaker Rupert Tomlinson, known as "Tom the Roller," was drinking with Philip Fair, an elderly man passing through town. The two got into an argument, probably over a gambling game, and Tomlinson hit the stranger over the head with a whiskey bottle. The bottle broke, and the attack continued, with the older man getting the worst of it. Fair survived the assault and filed criminal charges against his attacker. But as the trial date approached, Fair began to lose interest in his case. Many felt that he was being intimidated and pressured by local criminals not to testify. The tactic worked, and the victim refused to take the stand against his assailant at the trial. Tomlinson was found not guilty. The community was not happy that Tom the Roller walked free, complaining that because

Si Lovern's Saloon, located at Main and Garden Streets in Visalia, was housed in a building that had been built in the 1850s. In 1882, a writer for *Harper's* passed through Visalia and made a line drawing of the Mooney Brewery, which was the building that later became Lovern's Saloon. This image appeared in the *Harper's New Monthly Magazine* in November 1882.

Fair refused to testify he was not much better than his attacker. Expressing the sentiment of the town, the local newspaper demanded, "Such persons as Tom the Roller and his ilk, Fair included, should be ordered to leave town bag and baggage."[57] Already people were connecting Si Lovern and his saloon with undesirables and problems.

Also in 1892, Lovern acquired a second saloon at Sequoia Mills, a logging camp in the mountains of Fresno County. On November 16, Celia Miller, a Visalia prostitute who apparently was working there, decided to end her life by shooting herself in the head with Lovern's .38-caliber pistol. According to Lovern, the young girl's death had been reported to the Fresno County coroner, but he received no response, so he took her body to Visalia. Tulare County coroner J.R. Pendergrass completed an autopsy and declared her death a suicide. The young girl was buried at the Visalia Cemetery in a plot owned by Lovern. A few days later, upset by the removal of her body from Fresno to Tulare County, the Fresno coroner charged Lovern with "body snatching." The charges were eventually dropped, but again the name Lovern was associated with questionable activities.

A few months later, Lovern and his Visalia saloon made news once more. A man named Louis Daley visited a Chinatown saloon and slashed a tough guy named Walter Johnson. After the attack, the knife-wielding man wandered over to Lovern's Saloon and made the mistake of boasting about his "ability to artistically carve the toughest man that walked the earth." Lovern disagreed with his bragging claim and took the opportunity "to dust the floor with the vain boaster."[58]

Increasingly, Lovern's Saloon became a hangout for criminals and desperadoes drawn there by other unsavory characters and vile activities. They obviously were not patronizing the liquor establishment because of its classy décor or pleasant atmosphere. The old wooden saloon building was in terrible condition. The interior walls were lined with stained photographs of boxers and brawlers and old, faded pictures from *Police Gazette* magazine. The odor inside reeked of stale smoke and sour alcohol, and the floor was covered with sawdust soaked with tobacco juice. The back room contained a card table, a makeshift stage, a scratched-up old piano and some chairs, many of which were broken. There were rotting planks on many parts of the floor and holes in the shake roof. Behind the saloon was a small building known as the "Little Brick House," where Lovern lived.

On June 15, 1893, Lovern reported a burglary at his saloon, claiming that two Winchester rifles were stolen. It was later discovered that the rifles were in the possession of a man named William Fredericks, a violent criminal who had spent time in Visalia and frequented Lovern's place. Fredericks eventually took the guns north and used them to help convict George Contant, brother to John Sontag, in his attempt to break out of Folsom Prison on June 28, 1893. Some believed that Lovern falsely reported a burglary of the guns to hide his involvement with Fredericks, who was later executed in San Quentin for an unrelated murder.

Another incident took place in 1893 and brought more community scorn to the saloon. At about 2:00 a.m. on November 18, a twenty-eight-year-old San Francisco man named Lockhart was playing cards with forty-eight-year-old Tulare County assessor Frank Coffee. Both men were drinking, and a dispute started over the poker game. Harsh words quickly turned to violence. With a single blow from Lockhart's right fist, Coffee was knocked through the doorway of the saloon and onto the sidewalk. Lockhart was arrested for assault, but the next day, Coffee died from his injuries, so the charges against him were upgraded to manslaughter. The Tulare County district attorney decided not to prosecute, and Lockhart went free.

Sometimes the saloonkeeper's problems were not directly related to his saloon. In January 1894, Lovern became entangled in a bizarre dispute over a footrace. The two runners, strangers to Visalia, each put up $500, with the winner to take all. Travis Pendergrass, a young Visalia man, was selected as referee, and Lovern was asked to officiate at the finish line. At race time, more than one hundred people lined the seventy-five-yard course laid out on East Street (now called Santa Fe). Both runners were in good physical condition and ran hard. According to almost everyone in attendance, one

runner was the clear winner; however, both Pendergrass and Lovern saw it differently. They awarded the cash prize to the obvious loser of the race. The decision was not received well by the crowd. Both Pendergrass and Lovern were accused of having a financial interest in the race outcome, so the true winner of the race filed fraud charges against the two race officials. Both Pendergrass and Lovern were arrested and later released, but the controversy added another black mark to Lovern's name.

In about 1895, Lovern brought in Charles Ardell as a partner in his saloon. By this time, both Lovern's reputation and that of the saloon were badly tarnished. The community's opinion of the liquor establishment had dropped to the point that it was being openly called a deadfall, a dive and a disreputable joint.

In October 1895, twenty-year-old Obie Britt arrived in Visalia from Texas. He was industrious and came from a good family. While looking for work, Britt met forty-four-year-old Daniel McCall, a local wood chopper. The two got along well, and McCall asked Britt to be his partner in a wood chopping contract at Ben Hicks's ranch just north of Visalia, and Britt agreed.[59]

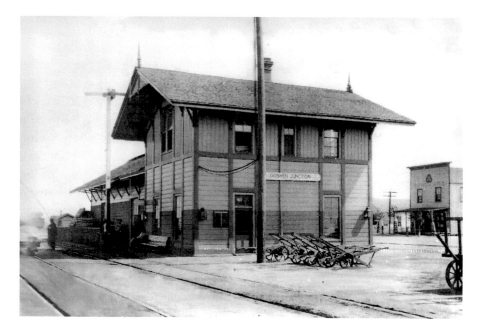

When the Central Pacific and the Southern Pacific railroads bypassed Visalia in 1872, they created the town of Goshen. It was near this depot almost twenty-five years later that a deadly shootout took place between robber McCall and Tulare County sheriff's deputies Daggett and Reed, image circa 1900. *Tulare County Museum.*

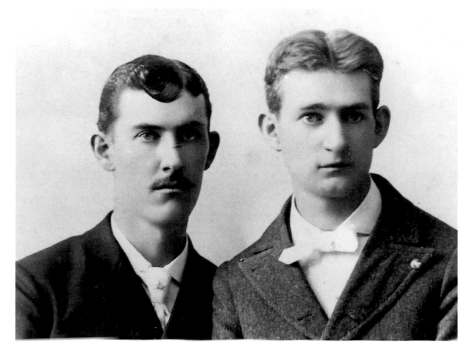

In 1896, Earl H. Daggett, Tulare County undersheriff (left) and Deputy George Victor Reed secretly boarded the train and waited for robber McCall to appear. Both deputies were shot in the resulting gunfight but survived their injuries. McCall was not as lucky, image circa 1895. *Annie R. Mitchell History Room, Tulare County Library, Visalia, California.*

As the two worked together, McCall mentioned a plan he had to rob a train and get some quick cash. The idea shocked the law-abiding young Texan, but he listened. McCall continued to share details of the plan with Britt and set March 19, 1896, as the date to attack the Southern Pacific train just outside Goshen. McCall mentioned to Britt that he had made arrangements for weapons and ammunition with Si Lovern and his saloon partner, Ardell. McCall did not realize that Britt was merely pretending to go along with the plan. From the beginning, the young man had been passing on the information about the criminal plan to Tulare County sheriff Alfred P. Merritt.

The evening before the planned early-morning holdup, McCall and Britt made their way to Goshen and hid, waiting for train no. 19. As the train arrived, and without the knowledge of McCall, Tulare County undersheriff Earl H. Daggett and Tulare County deputy sheriff George "Vic" Reed quietly slipped onboard the train. Armed with shotguns, the lawmen hid in the stack of coal

Dan McCall, a Santa Cruz County native, planned to rob the Southern Pacific train just after it pulled out of Goshen. He didn't expect Tulare County deputies Daggett and Reed to be waiting on the train to ambush him. McCall's miscalculation cost him his life. This line drawing of McCall appeared in the *San Francisco Call* newspaper on March 21, 1896.

on the tender. Shortly after midnight, as the train slowly left the Goshen Depot heading south, McCall jumped aboard and Britt pretended to follow, but he actually never boarded the train. As the train neared Tagus, just a few miles away, McCall put on his mask, readied his rifle and revolver and made his way to the tender. He approached the engineer and ordered him to "hold up your hands."[60] As the heavily armed bandit covered the engineer, the concealed lawmen challenged the surprised gunman, and gunfire erupted. Both Daggett and Reed were hit, but Daggett was still able to get off a shot. He hit McCall with a single fatal shotgun blast, and the robber fell off the train. The robbery was averted, and the two deputies survived.

Ardell and Lovern were arrested as conspirators in the train robbery plan and were placed in the county jail. On March 23, 1896, Lovern was given a razor to shave, but instead he used it to cut his own throat. The suicide attempt created a big commotion in the jail, and deputies rushed into his cell. Dr. T.J. Patterson was called, and he was able to stop the bleeding. Although Lovern was not expected to live, he survived his almost fatal wound. There was immediate speculation about his motive. The Sacramento newspaper reported, "Lovern's act seems to have been the result of a fear of lynching. Charles Ardell, his accomplice, said that they had fully expected an attack on the jail at any moment."[61]

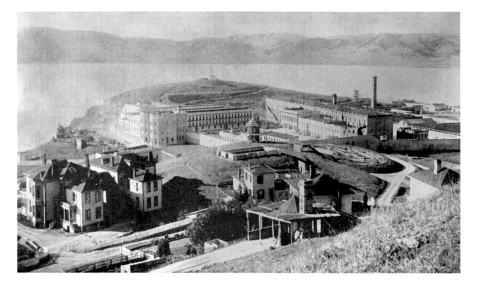

After Lovern's conviction, he was sentenced to life in San Quentin State Prison. Shown here in 1903, it is California's oldest, built soon after the Gold Rush on Point San Quentin near the San Francisco Bay. *California State Printing Office, Sacramento*

Lovern's arrest and incarceration proved to be more than his saloon could handle. The doors to Lovern's Saloon were closed for good in March, and the following month, the property was sold.

Lovern was tried and convicted for his role in the train robbery, and on June 29, 1896, he was sentenced to life in San Quentin. Ardell was later acquitted of his charges. Although some wanted Lovern to get the death penalty, most people were satisfied with the sentence. The local newspaper reported on the community feeling:

> *The whole community was thrown into ecstasies of delight by the decision of twelve of our fellow citizens. In this case, the criminal on trial was one who has lived amongst us a number of years and who has been the instigator and abettor of more crimes, great and small, than any other person who has dwelt amongst us; and the pursuit, arrest and trial of his criminal pals have been a great source of expense to the law-abiding citizens than any other item. Every person was thus interested in the trial and all but the immediate friends of the arch-criminal were overjoyed on hearing the verdict.*[62]

After an unsuccessful appeal, Lovern entered San Quentin on December 28, 1897. Within a few years, he had hooked up with nine other ruffians,

Lovern entered San Quentin State Prison on December 28, 1897, as convict no. 17570. His first years there were difficult, made that way in part because of his failed prison escape. *California State Archives, Sacramento.*

including Chris Evans's old partner, Ed Morrell. The men tried to escape but failed, and in 1899, Lovern was ordered to be confined in one of the soon-to-be-completed incorrigible cells at the prison.[63]

Lovern remained behind bars in San Quentin until 1912, when he was paroled. In 1932, the eighty-year-old former badman was given an unconditional pardon by Governor James Rolph. In doing so, the governor said, "He hasn't many more years to live and I am wiping this stain off his record in order to permit him to vote again as a free citizen of the United States."[64]

While in Visalia, Josiah Lovern lived life on the edge, and he had the scars to prove it. After his release from state prison, he returned to Tulare County and, for a time, lived in Three Rivers, but his last days were spent in the Old People's Home in Visalia. On April 6, 1937, one of Tulare County's most colorful characters died at the age of eighty-four and was buried at the Visalia Cemetery beside Celia Miller.

Hog Rogers Becomes Food for King

In 1852, a huge portion of southern Mariposa County was chopped off, creating Tulare County. The new county, although sparsely populated, contained thousands of square miles of land stretching east to the Utah Territory line (now the Nevada state line) and took in a big part of the Owens Valley. The mean Hog Rogers died a gory death at the hands of a ruthless killer in this beautiful but dangerous valley in 1865.

In the early 1860s, J.N. "Hog" Rogers, a former pig farmer, lived in the Owens Valley on Cottonwood Creek near Owens Lake. As hostilities with the local Native Americans heated up, other ranchers left, but "Rogers seemed determined through all of the Indian troubles to stick to the valley and in fact he is the only man now living at the Owens Lake with one exception, that being a man in his employ."[65]

Rogers was not on friendly terms with the local native people, and in fact, they despised one another. In January 1865, he joined a group of white settlers that, apparently unprovoked, slaughtered a number of Indians at the lake. Possibly as retribution, the following month Rogers was attacked by an Indian party while he was hauling hay. Hit with six arrows, he fought off his attackers with his pistol and miraculously survived.[66] There was no question about it. Rogers was made of rough stock. Erastus Warner, an early Tulare County pioneer, knew Rogers and said, "That old man 'Hog Rogers' was the meanest man I ever seen. He always carried a six-shooter and an extra cylinder around his belt so that he would have twelve shots."[67]

His place at the Owens Lake served as a way station, offering travelers meals and a place to rest. Sometime in early 1865, E.L.N. King paid him a visit, and

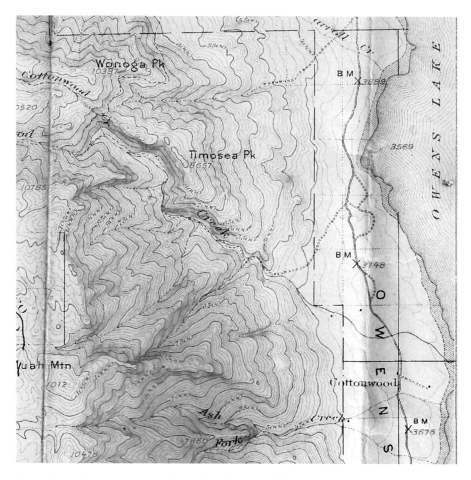

Before Inyo County was created in 1866, a big part of the Owens Valley was in Tulare County. Hog Rogers lived on his ranch at Cottonwood Creek near the Owens Lake. In 1865, Rogers was killed here in a most gruesome way. *U.S. Geological Survey, Olancha Quadrangle, 1907.*

Rogers hired him as a ranch hand. Very little is known about King other than he had lived in Petaluma in the 1850s, was married there and was a member of its local militia in 1857. Some said that he was a Methodist preacher.[68]

In May 1865, people noticed that Rogers had not been seen at his ranch for a while. They asked the thirty-seven-year-old King about his boss and noticed that his stories were evasive and inconsistent. To some, King said that Rogers was organizing a guerrilla band and had gone to San Francisco to buy arms. To others, King claimed that he bought the ranch from Rogers. The inconsistencies raised questions, and a number of people suspected foul play.

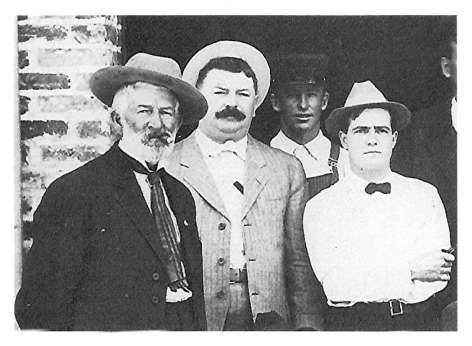

Erastus Warner came to Tulare County with his family in 1858. Ras, as he was called, was a member of the Visalia Volunteer Fire Department and was recognized as a skilled well borer. His boring talent was also used over much of the Southern Pacific Railroad lines in bridge construction. *Left to right*: Erastus Warner, Charles Berghold, Robert Board and Morley Maddox in 1909. *Author's collection.*

This suspicion led to a search of the ranch and discovery of Rogers's mutilated and dismembered body. There are several versions of how the gory discovery was made. One story has a visitor smelling a terrible odor and finding the rotting body of Rogers behind the ranch house. Another story alleges that King served a meal to a visiting doctor who discovered that he was eating Rogers's flesh. Yet another is cited by Captain James Hobbs, an early Tulare County miner, trapper and soldier of fortune. He wrote that once suspicion was raised, he and some friends searched the house, found a bloodstain on the floor and later discovered the body of Rogers under some floor planks.[69] Regardless of the conflicting details in the various versions, all stories pointed to King as the killer.

On July 6, 1865, Thomas Passmore, justice of the peace and acting Tulare County coroner, held an inquest. After deliberating a short time, the jury found "that the deceased was named J.N. Rogers, was a native of the United States of America, aged about fifty years; that he came to his death

on or about the 25th day of May, 1865, in this County, having been killed on his ranch by an ax, or some weapon in the hands of a person known by the name of E.L.N. King, and that the body had been cut up and portions of it consumed by fire." The coroner added to the inquest report:

After collecting the remains of the scattered pieces [of the body] *that were not consumed by fire, by close inspection of the mutilated head and face, it was found that a small portion of hair yet remained on the back of the head, the color of the hair, and being mixed with gray hairs, was that of J.N. Rogers, and by inspecting the mouth by the peculiar formation of the jaw and teeth, was no other person but that of J.N. Rogers, and by the confession of the prisoner* [King], *that he killed J.N. Rogers.*[70]

The *Visalia Delta* also weighed in on the horrific crime:

The most diabolical murder we have heard of in many a day, is that of J.N. Rogers at Big Owens Lake. The murderer who was working for Rogers, not content with killing and burying his victim, as most villains would have done, seems to have exercised his ingenuity for horrible modes of disposing of the poor remains of the murdered. He cut off his head, splits it open and feeds the brains to his dog, he hews up the fleshy portion and feeds them to his chickens and hogs, he burns portions of the body, while other portions are scattered in various portions about the house, until the disgusting effluvia attracts the attention of every passer-by. His evil genius seems to have prompted him thus to expose his crime until he is finally involved in such a net of evidence as to preclude a possibility of his escape. Poor wretch! With the odor of decaying mortality constantly around him, with the slowly decaying members of his victim, meeting his mental gaze every direction, with the constant presence of his friend murdered for so small a consideration, how utterly miserable must he have been.[71]

But one account of the killer's gruesome crime goes much further than that of the *Delta* or the coroner's inquest report. Some believed that not only did King cut Rogers's body into pieces and feed them to the farm animals, but he also jerked some of the dead man's flesh and fed it to visiting travelers passing by. Commodore Murray, pioneer resident of Tulare County, believed that he had eaten some of Rogers's jerked flesh as he was traveling through the Owens Valley around the time of the crime.[72]

After King's arrest for murder, he was quickly taken to Camp Independence, a military outpost near the little town of Independence. He was locked up in the guardhouse before an angry mob could get him. The camp was primitive, made up mostly of adobe buildings. While civilian authorities arranged for the prisoner transfer, King cleverly escaped from his military lockup. The *Delta* newspaper reported, "King, who murdered J.N. Rogers in such a horrible manner at Big Owens Lake, a few days since, has escaped from custody and taken to the mountains. He was in [the] charge of the military at Camp Independence… and having obtained some liberties under the pretense of insanity, he availed himself of them to make his escape."[73]

King didn't waste any time leaving the area. He headed south back to Owens Lake and then traveled west, crossing the Sierra. Once in the San Joaquin Valley, he found work at the Hamilton Ranch on the Kaweah River roughly nine miles east of Visalia. King used the assumed name of Walker.

On September 6, 1865, while hiding from authorities, he took time to vote in the Tulare County election at the Woodsville precinct. While voting, Lud Bacon recognized him and notified the Tulare County sheriff. Deputy Sheriff Harry Chapman arrested King at the Hamilton Ranch later that same day, and King freely admitted that he was the wanted man.[74]

However, Captain James Hobbs had another, much more exciting version of the second arrest of King. Hobbs claimed that he had been appointed temporary deputy sheriff to hunt down King after his Owens Valley escape. Hobbs and his special posse trailed King toward Visalia. Hobbs wrote:

> We followed on to a place called Visalia, hearing nothing further of him, and had nearly given up finding him; but on going about two miles further, we came to a grove where a camp meeting was being held, and stopped to make some inquiries for the man. Here we found him, preaching to the people from the stand. I could not be mistaken in the man, for I had often seen him at Lone Pine and at Rogers's ranch. I made my way to the stand, and, placing my hand on his shoulder, informed him that he was my prisoner. Recognizing me as coming from the vicinity where his crime was committed, he attempted to draw a pistol from his pocket. I had my hand on my revolver when I touched him on the shoulder, and I at once struck him on the head with it, knocking him down. Great excitement now existed all over the campground, the brethren asking me for what reason I was treating a brother in that manner. I then ran my hand in his breast pocket and secured his small revolver, which I held up to the astonished gaze of the people, and asked him if it looked very ministerial to be preaching with such a weapon

in his pocket, and informed him that I had a warrant for his arrest as thief and murderer.[75]

The captain's account of the King incident includes, at best, some verifiable elements, but much of Hobbs's account appears to be questionable.

After King's second arrest, he was taken to the Tulare County Jail in Visalia. The lockup was a primitive arrangement of cells on the ground floor of the two-story courthouse building. Security was a concern with the jail, and the *Visalia Weekly Delta* newspaper led the criticism:

Our jail is rather a poor excuse for the purpose for which jails are commonly used and nothing but extreme vigilance kept on the part of the officers ever keeps anyone. The prisoners are kept in irons and are let out of the cells during the day for change and exercise. Our jail ought to be more secure, as its present condition entails great expense in the way of guards, besides be a source of constant anxiety to our Sheriff and his excellent subordinates.[76]

On September 10, 1865, the Tulare County Grand Jury indicted King for murder. The indictment prepared by District Attorney S.A. Sheppard read, "That said E.L.N. King, on the 25th day of May, A.D., 1865, at the County of Tulare, State of California, did with a loaded pistol, unlawfully, feloniously and with malice aforethought, shoot, strike and mortally wound one J.N. Rogers, a human being."[77]

While King was in the county jail, he made an unsuccessful attempt to escape. On October 4, 1865, the *Delta* commented on his attempt in an article it titled "Possoming":

As the Deputy Sheriff [Harry Chapman] went to the cell of the murderer, King, on Thursday last, he found him apparently dead. After trying to rouse him, he locked the door and went for Dr. Martin Baker. When the twain returned, they found the scoundrel still inanimate. They tried various means of restoration when it was suggested that he was probably shamming. They then poured water in his nostrils, when he immediately sprang up and laughed heartily at his trick. He had evidently calculated that Chapman would hurry off for help leaving him an open agress [sic], which sage calculation was not justified, and Harry locked the door behind him. This does not look much like insanity.[78]

At the end of October, King's trial for the murder of Rogers began in the District Court in Visalia with Judge J.M. Bondurant presiding. George S. Palmer represented King, and District Attorney S.A. Sheppard represented the people. Jury selection proved difficult, as the gory nature of the case had been widely reported by the newspapers, so finding unprejudiced jurors was difficult.

Once a jury was selected, the testimony began. Witnesses described as "men of strong nerve" testified under oath and left the courtroom obviously moved by the gruesome nature of the case. The *Visalia Weekly Delta* reported, "The evidence was plain, concise and harmonious, having a well laid scheme to murder for the purpose of obtaining the property of the murdered. The details were perfectly sickening in their character, showing a degree of brutality and fiendish, unpitying cruelty scarcely equaled in the annals of crime."[79]

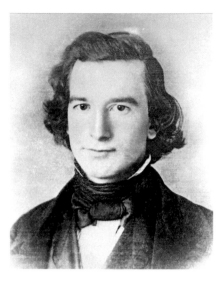

S.A. Sheppard began as Tulare County district attorney in 1863 and served until 1866. As DA, Sheppard was scolded by the Tulare County Grand Jury for being under the influence of alcohol and therefore "unable to give us legal advice." But it didn't seem to hurt his career because in 1869 he was appointed Tulare County judge, image circa 1865. *Author's collection.*

The defense presented little at the trial, and after a week, the case was given to the jury. The members quickly returned a unanimous verdict of murder in the first degree. Palmer raised an insanity defense, but the court rejected it. The judge wasted no time and sentenced King to be hanged by the neck until dead. The convicted man was ordered to be returned to the county jail to await his execution date, set for December 12. Local carpenters Travis and Strong were hired to build the scaffold and gallows next to the courthouse, with a twenty-foot-high enclosure surrounding it. The carpenters were paid sixty-eight dollars for their work.

On the day of the execution, Reverend Dr. James Alonzo Webb visited with the condemned man for several hours. At about 3:00 p.m., King was taken from his jail cell to the awaiting gallows. As he stood on the platform, he gave a long, rambling speech to those in attendance. At 3:20 p.m. on Tuesday, December 12, 1865, with the local Home Guards standing by for added security, the drop fell, ending the life of one of Tulare County's most gruesome killers.

Mason-Henry Gang

Cutthroats Through and Through

T he two ruthless killers and their associates were so evil that they turned brutality into a fine art. The mere mention of the Mason-Henry Gang would cause people to tremble. They claimed a fierce loyalty to the Southern cause and the Confederate flag during the Civil War, but most believed that they used their allegiance as an excuse to intimidate, rob and murder.

The ringleaders of the gang were John Mason and James Henry. Born in about 1835, John Mason, also known as John Monroe, was stocky, stood about five-foot-seven and weighed nearly 170 pounds. He had a large scar on his cheek, red whiskers and walked with a limp. He wore a unique hat made out of a coyote skin, with the tail standing up in the front. He always carried a six-shooter and a butcher knife, and in about 1859, he supposedly killed a man while living at Fort Tejon. Born in Illinois in about 1833, James Henry, whose real name was Tom McCauley, stood about five-foot-nine, was slender and weighed roughly 145 pounds. He had stooped shoulders, dark hair and a heavy beard. Henry, like his partner, carried a six-shooter and a butcher knife[80] and also boasted a criminal past, having served time in San Quentin for murder.

Mason and Henry were brought together and financed by a wealthy Stockton businessman who was a committed secessionist. When the War Between the States broke out, the two reportedly held a recruitment meeting on Cottonwood Creek near the Kern River Canyon, then part of Tulare County. They told the large group in attendance that they were forming a company of fighters to join the Confederate army. Once it was discovered that the true intent of the group was criminal activity, many chose not to become involved.[81]

Most of the Mason-Henry Gang members' deadly deeds seemed to have taken place in the later years of the war. However, they are credited with an earlier robbery and murder, perhaps about 1861, at the Butterfield Stage station at Mountain House (or Willow Springs, as it was sometimes called). According to legend, four or five people were killed by the gang, and the deadly confrontation became the basis for many ghost stories connected to the old stage stop.[82]

In 1864, the activities of the gang began in earnest and seemed to coincide with the reelection victory of President Abraham Lincoln. In November, the gang visited the little town of Fresno. While the two men were there, a San Francisco newspaper reported, "The infernal villains, Mason and Henry, proposed murdering a man of the name of John Chichester at his place, but on their arrival some teamsters were encamped here, which deterred the murderers from commission of the foul deed."[83]

Also in November, the gang rode to Hawthorne Station, a stage stop in Fresno County. When Union loyalist Joseph Hawthorne, the station operator, greeted the pair, it was reported that he was "foully and barbarously murdered on the spot."[84]

A short time later, Mason and Henry visited Elkhorn Station, another stage stop on the Fresno Slough. It was run by a man named E.G. Robinson, who had allegedly made unflattering remarks about Southern women. The report of his derogatory comments made it to the gang, and they paid him a visit. The newspaper reported, "In the presence of his wife and little helpless children, Robinson, amid tears and supplications, on bended knees, was most foully, cruelly sent to that 'bourne whense no traveler returns.'"[85] Their murderous rampage continued, and a short time later, another Union man named Charley Anderson was brutally shot at his place on the San Joaquin River.[86]

The string of savage murders was widely reported, and the Mason-Henry Gang was given full credit. California governor Frederick F. Low wasted no time in offering a reward of $500 for the "arrest of each and every person engaged in the commission of the murders."[87]

Although gang members oftentimes concealed their membership, sometimes word got out and identities were discovered. Peter Worthington (or Jack Gordon, as he was known) was a member of the gang, and not surprisingly, the tough guy had a violent past. He lived near the little mining town of Tailholt and cultivated the respectable appearance of a hog farmer. Many saw through his cover and suspected that his business was merely a plan to hide his gang involvement and criminal behavior.[88] One day in December 1864, Gordon and his former business partner Samuel

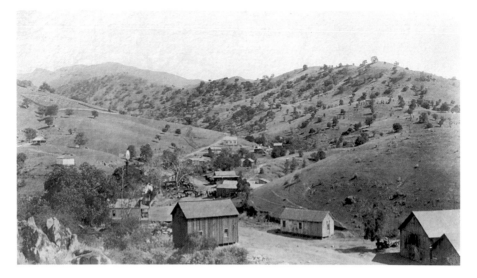

Tailholt, or White River, as it was later called, was started in 1856 as a mining settlement on the White River. The area never produced much precious metal, so the town slowly died. However, it did survive long enough to have a boothill cemetery—the final resting place of Jack Gordon. Annie R. Mitchell, one of Tulare County's premier historians, was born here in 1906, image circa 1896. *Author's collection.*

Groupie had a dispute on the streets of Tailholt. Groupie pointed a shotgun at Gordon, threatening to shoot him. Gordon claimed to be unarmed and asked for time to arm himself, but the man did not wait. He fired his shotgun straight into Gordon's stomach. Struggling, Gordon made it to his gun and returned fire, also hitting his assailant in the stomach. Gordon died from his injuries and was buried at Tailholt's boothill cemetery. Groupie recovered.[89]

The gang was drawn to Tailholt and had a hideout in the nearby hills:

> *Mason and Henry had a retreat over on the Blue Mountain quartz ledge on Grizzly Gulch. Near the top of the ridge they had excavated a large room. This room would hold three or four horses and as many men. A hole was dug from the excavation to the surface above and was used as a chimney.*
>
> *When they would do some robbing or murdering, they would disappear and travel through the heavy brush to this room. There they would hide themselves and their horses until people were tired of looking for them.*[90]

As their reign of terror continued, lawmen, soldiers and others took up the hunt. A Visalia newspaper reported on one squad of soldiers from Camp Babbitt that had just returned from a twenty-five-day manhunt. The *Delta* announced:

They report very hard skirmish, traveling over 900 miles through a most desolate country; upon several occasions going two and three days without food for themselves, or forage for their horses. They were several times on their trail after they left Fort Tejon and finally tracked them into Sonora, where they were compelled to give up the chase on account of their horses giving out and their inability to get fresh ones. The fugitives were well supplied with gold, having $8,000 or more in their possession. It is believed by many that they have gone to recruit a guerrilla band, and will return to prey on Union men in the lower part of the State. They could have obtained plenty of recruits nearer home. Doubtless Visalia would have furnished several birds of prey and a surgeon or two, to bind up their broken heads, and very likely a Chaplin [sic] to minister to their bruised souls, and any number of spies, sneaks and informers. As to good fighting men, they would have been scarcer hereabouts.[91]

Despite the intense search, the gang evaded capture and continued to terrorize. Newspapers tracked their activities and whereabouts:

In October 1862, fifty-seven California Volunteers arrived in Visalia and began a military post called Camp Babbitt. The town strongly supported the South in the Civil War, so the soldiers came to help maintain order. Troop levels fluctuated reaching up to several hundred at its peak. This image was reportedly sketched by a soldier stationed here in 1863. *Author's collection.*

A portion of the Mason and Henry gang of cutthroats and horse thieves paid a visit to Snellings, in Merced County, on Saturday last, April 8, on a horse stealing expedition, having stolen some fine horses on the Merced. They robbed a Jew's store at a place called Forlorn Hope. In passing under the Visalia telegraph line, nine miles north of this place [Firebaugh's Ferry, Fresno County], they broke down the wire and carried away a portion of it. Sheriff W.L. Coats, of Merced County, with a posse, are in hot pursuit, and will make this section of the country uncomfortably warm for the band. Henry was seen in this vicinity on Saturday last, April 8, and it is supposed Mason is with him. The rendezvous of this gang is some place in the Pacheco Mountain, about 45 miles South East of South San Juan [San Juan Bautista].[92]

The loosely organized gang seemed to be everywhere. At sundown on July 13, 1865, John Mason and gang member Thomas Hawkins paid a visit to Philo Jewett at his sheep ranch on the Kern River. Jewett, a Union man, graciously invited the two strangers to spend the night. But before the rancher realized his mistake, he was grabbed, and a pistol was pointed at his midsection. Somehow Jewett broke free, jumped through a ranch house window and hid in the nearby brush, leaving his cook, John Johnson, in the house alone with the two men. While hiding, Jewett heard a gunshot, ran back to his house and saw Johnson lying dead on the floor. Not only was he shot, his back and chest were also slashed with a knife. The home was ransacked, and two rifles were stolen. Tulare County deputy sheriff Harry Chapman happened to be in Bakersfield at the time and organized a posse to pursue the killers, but they escaped.[93]

The people of California became more and more frustrated with this ruthless gang and their ability to operate freely. The *Visalia Weekly Delta* expressed the concern that many felt:

We are getting disgusted with chronicling the depredation of these two scamps and begin to think that if they can be secured neither by official nor private effort, by military nor civilians, that the honest portion of this community had better sell out and give the valley to Mason and Henry... These scoundrels seem to hold the authorities in utter contempt. They go and come at their leisure and take life as easy as though there are no such institutions as jails.[94]

Shortly after the Johnson killing, the Tulare County Grand Jury met and indicted Thomas Hawkins for the murder. On July 26, 1866, Tulare County

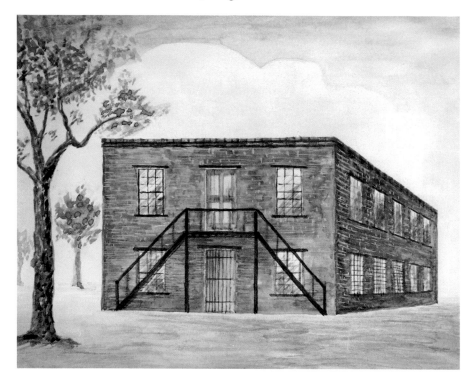

The county jail in 1865 was the ground floor of the Tulare County Courthouse building. Built in 1858, the structure served as the courthouse and jail until 1877, when a much larger and more ornate facility was finished. No actual photographs of this building exist; however, this represents an artist's rendering based on descriptions provided by people who saw it. The building was located at Courthouse Square in an area bounded by Court, Oak, Center and Church Streets, image circa 1860. *Author's collection.*

sheriff Tilden Reed discovered that Hawkins was already in custody in Los Angeles, apparently on unrelated charges. The sheriff picked him up and brought him to Visalia for trial. District Judge Alex Deering heard the case, and on October 27, 1866, Hawkins was found guilty of the murder and was sentenced to hang in Visalia on December 14.

On the day of execution, the sheriff took Hawkins from his cell in the county jail and escorted the condemned man to the nearby gallows platform. His arms and legs were tied, a hood was placed over his head and a noose was tightened around his neck. At the appointed time, the word was given, the trapdoor opened and Hawkins's body dropped. The dead man was turned over to the undertaker.[95]

The surrender of General Robert E. Lee to Ulysses S. Grant at Appomattox Courthouse in April 1865 marked the end of the Civil War

and the beginning of the end for the Mason-Henry Gang. As the war ended, the gang moved into Southern California and dispersed.

In September 1865, James Henry and about sixteen of his men, including John Rogers, were camped in the mountains near San Bernardino. Rogers went into town to purchase provisions for the group but first decided to do some drinking. As he drank, he began to divulge information about the gang and its leader. Rogers was soon arrested for his gang affiliation. As he was being prepared to be hanged, he told all he knew about the gang and its whereabouts. The San Bernardino County sheriff organized a posse, and the lawmen rode toward the outlaw camp. As the posse closed in, Henry "jumped up, with a six-shooter in each hand and started to run, firing at the crowd, but was immediately shot down, fifty-seven balls taking effect. Then they brought him to San Bernardino and took a photograph of his body and it was identified by some eight or nine men who said they knew him."[96]

A few months later, John Mason's crime spree also came to an end. While on the run, he spent time at Fort Tejon. One report noted that he was an unwanted guest at the Jack McKenzie place. Authorities were alerted to his whereabouts, and six men approached the house to make the arrest. Quietly, the men entered and shot Mason while he was in bed.[97]

His death made news all over the state. "Mason, the robber, shot," was reported in a San Francisco newspaper, which added:

> *Mason of the late robber gang of Mason and Henry, was killed a few days since in Tejon Canon by citizens. There appears to be but little doubt that this is the veritable Mason. Seems there were several of his gang together and they all got off except the Chief. Two of them were arrested at Clear Creek and taken to Los Angeles on a charge of murder committed in that county. Two more of the party are supposed to have passed through this place [Visalia] on Wednesday last hunting a place of refuge. A party, headed by Deputy Sheriff Duncan, started in pursuit of them yesterday morning.*[98]

Although some members of the old gang continued living lives of crime, the years of the dreaded Mason-Henry Gang were over.

James Wells

A Secessionist Street Fighter

The country was on edge as the War Between the States began. Although the violence was primarily centered on the battlefields of the East, California, a state officially aligned with the Union, had its share of hostilities as well. Visalia was especially dangerous. With its large and vocal rebel population, this Southern stronghold had a reputation as a rendezvous point for "rebel sympathizers, murderers, thieves and assassins," giving it the well-deserved title of the "Charleston of California."[99]

The long list of Civil War–connected incidents and skirmishes in Visalia started in 1860 and included bloody shootouts, high-profile arrests and the banning and eventual destruction of a newspaper. In August 1863, another incident was added to the list and again put the town and Tulare County in the national spotlight while also causing shockwaves across the country.

After all it had been through, the little town of 550 felt like a war zone in 1863, and still more fighting was on the way. At about noon on August 6, a group of soldiers, including Sergeant Charles C. Stroble and Private Jim Donahue, were walking along Main near Church Street. As they passed Tilden Reed, the drunken man yelled, "Hurrah for Downey," making reference to the Democratic candidate for California governor who was seen by many as being pro-South. Donahue responded to what he deemed a treasonous comment and quickly let the intoxicated man know that if he repeated it, he would shoot him. More words were exchanged, and James L. Wells, a prominent businessman and vocal secessionist who was standing nearby, joined in the heated conversation, siding with Reed, who would later be elected Tulare County sheriff. That day, though, Reed was arrested and taken to the guardhouse at Camp Babbitt.[100]

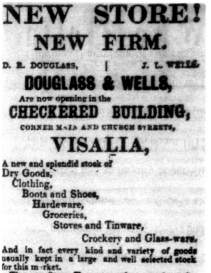

NEW STORE!
NEW FIRM.

D. R. DOUGLASS, | J. L. WELLS.

DOUGLASS & WELLS,

Are now opening in the

CHECKERED BUILDING,

CORNER MAIN AND CHURCH STREETS,

VISALIA,

A new and splendid stock of
Dry Goods,
 Clothing,
 Boots and Shoes,
 Hardware,
 Groceries,
 Stoves and Tinware,
 Crockery and Glass-ware.

And in fact every kind and variety of goods
usually kept in a large and well selected stock
for this market.

The new Store House recently erected on the
old site of the former store of D. R. Douglass, is
now completed, and they are opening an entirely
new stock of Goods, selected by one of the firm es-
pecially for this market, and which will be sold at
very reasonable prices. Both members of the firm
have been engaged in the mercantile business in
Visalia for several years, and well acquainted with
the requirements of the citizens. We invite every
body to Call and examine our goods, which we will
take pride and pleasure in showing at all times.
 DOUGLASS & WELLS.
Visalia, Sept. 8, 1860. 12 tf.

Left: James Wells was a Visalia businessman who during the Civil War supported the rights of states to secede from the Union. He had been a business partner with Solomon Sweet and Dave R. Douglass, but all that changed when he shot a Union soldier on the streets of Visalia. This advertisement was published in the *Visalia Weekly Delta* on December 1, 1860.

Below: Camp Babbitt was named for Colonel E.B. Babbitt, quartermaster general of the Department of the Pacific. It was a California Volunteer garrison established to keep the abundance of secessionists in line. But it wasn't all hostility and fighting. The troops found time to enjoy music and organized an eight-piece brass band in November 1863, image circa 1864. *Author's collection.*

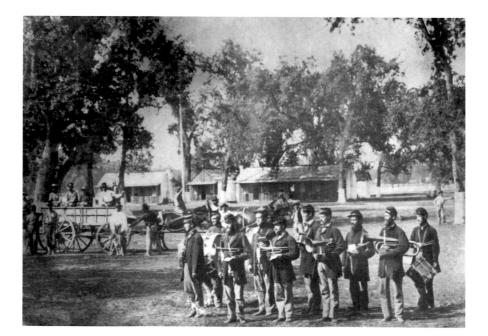

The soldiers continued walking on Main Street, with Wells following behind, obviously upset over the Reed incident. Stroble and Donahue entered the Knoble & Krafft restaurant, and as Wells walked by the entrance, one of the soldiers kicked a chair at him. Wells and Donahue exchanged angry words, and the three men moved into the street. Donahue drew his pistol, and "Wells raised both hands and said he had no arms but a pocket knife." Donahue turned and walked away, and as he did, Wells jumped "behind a pillar, drew his pistol and fired, first at Donahue and next at Stroble."[101] Stroble was hit but Donahue was not, and the private ran for cover. Stroble grabbed his chest, took a few steps and fell to the sidewalk. From a position of cover, Donahue returned fire, and roughly twelve shots were exchanged between the two men. The smell of smoke and powder filled the air, but neither Wells nor Donahue was hit. Wells ran through Henry Bostwick's tin shop and out the back to the Overland Livery Stable. He got a horse and rode out of town.

Stroble was carried back into the restaurant, where Dr. Martin Baker attended to the man, but he was already dead. Witnesses claimed that at no time did Stroble ever become engaged in the confrontation either verbally

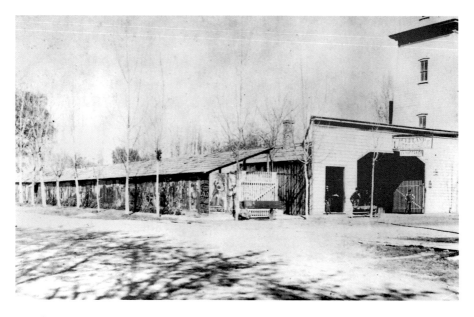

The Overland Livery Stable located at Acequia and Court Streets was convenient if quick transportation was needed out of town. Less than a block from the scene of the Stroble shooting, the Overland provided James Wells a horse for his hasty ride out of town, image circa 1880. *Author's collection.*

or with his pistol. Tulare County coroner T.J. Shackleford wasted no time empaneling a coroner's jury and conducting an inquest. After interviewing a number of witnesses and examining the body, the jury concluded that "Charles C. Stroble, was a native of Germany, aged 31 years, that he came to his death on the 6th day of August, A.D. 1863, by a pistol shot in the hands of James L. Wells."[102]

The next evening, Wells's Visalia home burned to the ground, obviously the work of an arsonist. The pro-Union newspaper reported:

> On Friday night last, the residence of James L. Wells, the murderer of Stroble, was totally consumed by fire. There is little doubt that it was set on fire, but by whom is the mystery. Himself [Wells] and friends have repeatedly declared that it should be burned to the ground, rather than be confiscated by the Black Republicans...On the other hand, the Union men

On the afternoon of August 6, 1863, James Wells shot Sergeant Charles C. Stroble on Visalia's Main Street. He was buried at Visalia Cemetery. His headstone is badly worn and simply reads, "Sgt. C.C. Stroble, Co. I, 2nd Cavalry." *Photo by Bill Dillberg, Visalia, California.*

were terribly exasperated, and some indiscreet ones may have applied the torch. This is a State's Prison business, and if the perpetrators are detected it will go hard on them. We hope no Union man has been guilty of conduct worthy of Jeff Davis' guerrillas.[103]

The news of the Stroble killing and the Wells fire traveled quickly, as telegraph messages sent from Visalia spread to newspapers all over the country. The Sacramento newspaper quoted one of the Visalia telegrams:

The excitement here is much increased this morning in consequence of Wells' house having been burned last night. The Secessionists declare that civil war has commenced and loudly threaten retaliation with fire. There is little doubt that Wells' house was burned by his friends as his wife removed all the furniture, etc. yesterday, declaring that she would rather see it burned to the ground than see it confiscated by the Black Republicans.

Sergeant Stroble was buried yesterday with military honors. The funeral was very largely attended. The soldiers are naturally very much exasperated, as he was a peaceable, inoffensive man, and a great favorite. The evidence shows that he did not speak a word or make a motion previous to being shot. The verdict was that he was killed by James L. Wells.

Unless troops are sent here within a very short few days, in sufficient numbers to overawe the Secesh the chances are that a terrible conflict will ensue, in which hundreds of lives will be lost. If the Secesh burn one house as they threaten, the Union men will drive them from the country or die in the attempt. They will have to do it in self-defense.[104]

Even East Coast newspapers received the news of the shooting, although the stories were oftentimes embellished. The *New York Times* reported:

On the 6th an affray occurred at Visalia, a small town in Tulare County, between the Secessionists and the soldiers stationed there. One of the latter was killed. Several of the former were wounded. Thirty-six shots were exchanged. Tulare and the adjoining counties in the southern part of the State, contain numerous Secessionists. At Visalia, great excitement prevailed. Some Union citizens, who organized as a home guard, and others, pursued the parties who had fired at the soldiers.

The house of the man who shot the soldier was burned down on the night of the 7th, which exasperated both Unionists and Secessionists, each accusing the other of the deed.[105]

When the local Visalia newspaper began to see and hear of the inaccurate and exaggerated national reporting, it expressed concern:

> *We regret to see that evil minded persons are filling the country, far and near with false and mischievous rumors, in reference to the recent painful occurrences in our town. We call these rumors dangerous because they continually excite the public mind, strengthen prejudices, already sufficiently bitter, add to existing animosities and widen the breach between different classes of citizens, and that way produce a vast amount of mischief. Were it not that those false tales are dangerous to the public peace, they are so ridiculously unreasonable that they would be laughable. Blood, murder, rapine, fire, torture and all imaginable terrors are so mixed and mingled as to make a perfect devil's broth of horrors. Editors at a distance pick up these tales and repeat them until the idea gets abroad that our people are perfect devils incarnate.*[106]

As Wells quickly left town, he rode east toward the swamps, pursued by soldiers. Reportedly, "Wells had narrow escapes from capture. At one time, when he was hiding under a log, several of the pursuing soldiers came up and sat on it. He wandered as far east as the Cottage post office, where his friend Jesse Reynolds, secreted him and supplied him with provisions. He later disguised himself, got to San Francisco and from there, went to Mexico."[107]

Some say that the killer was able to cross the border with financial help from Solomon Sweet, a former business partner. A few months later, a letter appeared in Visalia from Wells in which he wrote that he was in Mazatlan (Mexico) and avowed to stay there and become a citizen.[108] Apparently, he had second thoughts and wanted to return to the United States. He had relatives secure a change of venue for his murder case, and it was successfully moved to Merced County, where he was acquitted of all charges.[109] He never returned to Visalia.

The killing of Sergeant Stroble on that hot August day in 1863 left everyone anxious and uneasy. He had been a loyal Union soldier in a fiercely divided town, and then he was dead—killed by James Wells, a man with sharp political differences and a good aim. That deadly encounter would long be remembered, and their names would be forever etched in the violent history of Tulare County.

Jim McKinney

Porterville's Tough Guy

James McKinney was a brutal killer who for nearly two decades terrorized the people of Tulare County, the San Joaquin Valley and beyond. His wild and deadly gunplay left dead and wounded bodies strewn over a wide area.

McKinney was born in Illinois in about 1860 and later moved to Missouri with his family. In about 1880 they came to Farmersville in Tulare County and rented a farm. The young man worked on ranches and became a trained horseman—a skill that would prove helpful during his years on the run. He was likeable and considered a good worker,[110] although he had at least one early display of antisocial behavior. While attending a school program for his younger brother at Locust Grove School near Farmersville, for some unknown reason, he became angry and disruptive. When confronted by Deputy Constable Walter Boggan, he attacked the lawman, cutting him and leaving a deep gash.[111] The incident seemed to mark the beginning of a life of violence.

McKinney began to hang out in Visalia's notorious rough section called Spanishtown. He drank, gambled and frequented houses of prostitution there. It soon became clear that when under the influence, his pleasant disposition turned mean. In September 1886, while at a saloon in Spanishtown, he got into a fight with Lawrence Turner, and McKinney fired his pistol at him. He missed his target but instead wounded a nearby prostitute named Kitty Davis.[112]

Later that year, McKinney got into a scrape with Tulare County undersheriff Ed Fudge on the streets of Visalia. He drew his gun on the lawman and pulled the trigger, but it misfired. McKinney was charged with assault and taken to jail.[113] When he was released, he wandered from

Jim McKinney was a pleasant guy, but if you crossed him, especially if he had been drinking, he could quickly became a vicious killer. *Left to right*: Lawrence Whit, Jim McKinney and Ed Zalud, image circa 1889. *Jeff Edwards Collection, Porterville, California.*

town to town, including Porterville, Traver, Bakersfield and Merced. While in Merced, he became friends with Robert McFarlane and Alfred Hulse, two rough saloon types. The three began to run together, and eventually McKinney returned to Tulare County with his new companions.

On November 1, 1889, McKinney and his brother, Edwin, were visiting Tap Carter's saloon in Porterville. Edwin saw Lee Wren gambling and interrupted the game, demanding that Wren pay him money he was owed. When Wren refused, the two men began to fight, and Jim McKinney jumped in to help his brother. Charges were filed against McKinney for pistol-whipping Wren, and he was arrested on a warrant. An additional charge of assault was filed against him for drawing a pistol on Tap Carter in an earlier incident.

McKinney was placed in the Tulare County Jail in Visalia where he found his Merced friend McFarlane locked up as well. The two began planning a jailbreak.[114] With help from the outside, the pair escaped on November 25, 1889. They rode north, and at least McKinney left California. He was eventually found in Rawlins, Wyoming, arrested and returned to the county jail in Visalia. He stood trial on his past assault case and his jail escape. McFarlane continued on the run.

McKinney was convicted of all charges and given a seven-year sentence, and he entered San Quentin Prison on March 11, 1890. Many people saw

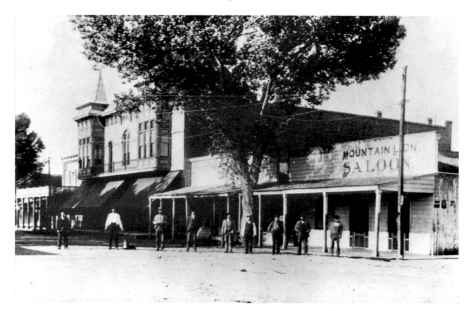

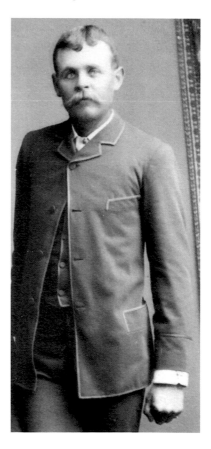

Above: The streets and hangouts of Porterville had a magnetic quality, and they kept calling McKinney back. It was hometown to him, and he left his violent calling card there so often. It was Bakersfield where his trail ended, but he made one last trip to Porterville, image circa 1895. *Jeff Edwards Collection, Porterville, California.*

Right: Jim McKinney could be dapper, but his clenched left fist gives away his savage side, image circa 1900. *Jeff Edwards Collection, Porterville, California.*

73

the sentence as excessive, and almost immediately an effort was made to get it reduced. The move was widely supported, even by Tap Carter and Lee Wren. Governor Markham, however, was not sympathetic to the request and refused to show leniency. However, eventually the Tulare County badman was released early, serving only four and a half years of his seven-year sentence. He returned to Porterville but soon headed east to Randsburg, a desert mining town in Kern County. He continued his previous pattern of drinking and gambling and had at least one bout with the law while there.

In about 1899, McKinney again returned to Porterville. He went to work for the Pioneer Water Company as a security guard, making sure its irrigation ditch water was protected. He began hanging around Porterville ruffian Tom

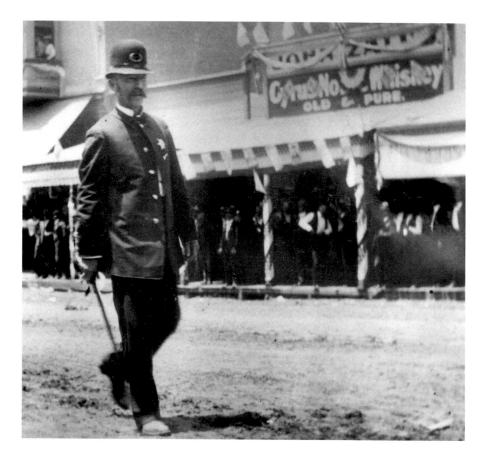

Porterville city marshal John Howell took part in the Fourth of July parade in 1902. The Main Street parade passed by John Zalud's Saloon on the far right. About three weeks after this photograph was taken, Howell and other lawmen had a gunfight with McKinney. *Jeff Edwards Collection, Porterville, California.*

Sears, also known as "Long Red." Sears had been living in Visalia but had moved to Porterville.[115] The two went to Fresno's tenderloin district, where they gambled and associated with the rough element. Later, they made their way to Bakersfield—an oil-rich boomtown at the time. In the early morning hours of December 13, 1900, after an evening of drinking, McKinney and Sears got into an argument. Both drew their pistols, and McKinney hit his mark, killing Sears instantly. McKinney was arrested for murder, and after the short trial in May 1901, he was found not guilty.

Again, McKinney returned to Porterville and worked as a bartender. His gambling and drinking continued, and on the evening of July 26, 1902, he made the rounds of the saloons in town. While at Scotty's Chop House, a restaurant and drinking establishment, he began wildly firing his pistol. One of the rounds hit a card room table next door at Zalud's Saloon, scattering poker chips everywhere. Billy Lynn, a patron at Zalud's, joined his friend McKinney at the Chop House, where the two had some drinks. A short time later, Deputy City Marshal John Willis walked in and sat down nearby, watching the two men. The lawman saw that more trouble was brewing and determined that an arrest was necessary. He left to get City Marshal John Howell and a few more men to assist. As the arrest team was about to enter the Chop House, McKinney stepped out onto the sidewalk with pistol drawn and began firing at the lawmen. They returned fire in an intense exchange. McKinney was wounded, as were two of the lawmen.

McKinney managed to make it home, where he picked up his rifle and shotgun. As he started back to the scene of the shooting, Billy Lynn was in his path. McKinney sent a blast from his shotgun into Lynn, killing him on the spot. McKinney then made it to the Arlington Stables, where he forced the hostlers to prepare two horses and a cart. As he quickly drove the cart out of town, he randomly fired shots down the street, wounding several bystanders.

Soon it was announced by the authorities that James McKinney was wanted for the murder of Billy Lynn. The wanted poster described the killer as follows:

Nativity, American; age 40 years; height, 5ft 7in; weight, about 160 lbs; hair, light brown; generally wears a heavy light mustache; he may grow a beard; eyes, blue, complexion florid; broad, square features; high broad forehead; short, thick nose; large mouth; short, square chin; large ears, well cut; two joints off left forefinger; was shot on July 27th, 1902, ball entering left thigh in front near crotch, passing through on inner side of bone, so there will be a plain scar on both sides of thigh; occupation, barkeeper and

gambler; may go to work on a ranch; he drinks and smokes; is quarrelsome when drinking and very handy with his gun.[116]

Feeling pressure from the manhunt, McKinney hid out at White River, an old Tulare County mining town once known as Tailholt. As his wounds began to heal, he crossed over the Sierra and returned to Randsburg. Afraid that he might be discovered, he crossed the border and headed for Hermosillo, Mexico. Tulare County sheriff William Collins learned of his Mexican refuge and crossed over the border in pursuit. He found his man, met with police officials and was granted permission to arrest McKinney. But just before making the arrest, Mexican authorities withdrew the arrest authorization. This delay gave McKinney the time he needed to leave Hermosillo and slip back over the border into the United States.

The fugitive hid out for a time in the little mining town of Cedar, Arizona.[117] While there, McKinney saw two men riding into town. Presuming that the two were bounty hunters, he shot and killed them, leaving their bodies alongside the road. He then began his trip back to the San Joaquin Valley. The Arizona killings brought Henry Lovin, sheriff of Mohave County, Arizona, and his posse into the hunt, and they followed the killer's trail into California. He alerted Tulare County sheriff Collins, Kern County sheriff John Kelly, San Bernardino County sheriff John Ralphs and Inyo County sheriff C.A. Collins as to the fugitive's direction of travel.

On April 10, 1903, McKinney was spotted riding west through Randsburg, and two days later, he was seen in Kernville. The constable there, Fred McCracken, was watching for him, and when he spotted the fugitive, he fired two rifle shots at him but missed.

By April 17, McKinney had made it to Bakersfield and had found his old friend Alfred Hulse. McKinney was tired and weak after his long trip from Arizona. Hulse got him dinner and offered him lodging at his place in the Joss House, a large two-story building with living units and a Chinese religious temple on the second floor. Word quickly spread of McKinney's whereabouts, and at about 10:00 a.m. on Sunday, April 19, 1903, lawmen surrounded the building. Kern County deputy sheriff Will Tibbet and Bakersfield city marshal Jeff Packard entered and searched the basement and then moved up to a first-floor room and knocked on the door. Receiving no response, Tibbet slipped a passkey into the door lock. But before he could open it, the door burst open, and the lawmen were face to face with the fugitive McKinney and a man believed to be Hulse. Immediately, the outlaws opened fire, and both Tibbet and Packard were hit by shotgun blasts.

Jim McKinney was killed by Kern County deputy sheriff Bert Tibbett on April 19, 1903, at the Joss House in Bakersfield. Two lawmen were also killed. Outlaw McKinney's body was laid out in a mortuary in Bakersfield and then taken to Porterville for burial. *Tulare County Museum.*

During the barrage of gunfire, other officers moved onto the scene. Kern County deputy sheriff Bert Tibbet, the younger brother of Deputy Will Tibbet, moved to assist the wounded city marshal. As Bert Tibbet did, he spotted McKinney, fired his shotgun and hit the outlaw in the neck, knocking him down. The wounded badman got back up and ran into a nearby room. When Bert Tibbet saw his wounded brother lying on the ground, McKinney appeared again. Bert Tibbet fired another shotgun blast at the outlaw, this time killing him instantly.

Both Deputy Will Tibbet and Marshal Jeff Packard died in the Joss House incident. The violent shootout that morning made news from Nebraska to New York. Outlaw McKinney's life was over. His reign of terror ended that Sunday morning "when Bert Tibbet exterminated the last of the old-style badmen with two well-aimed blasts from his shotgun."[118] McKinney's body was returned to Porterville, where he was buried at the city cemetery beside his father.

Evans and Sontag

Visalia's Notorious Train Robbers and Killers

In 1880, settlers living on land owned by the Southern Pacific in the Mussel Slough District of Tulare County were evicted in a deadly confrontation that rattled the entire nation. The incident, believed by many to show Espee brutality, lasted just a few minutes, but the impact on railroads would be felt for years. So, a decade later, when Christopher "Chris" Evans and John Sontag were accused of robbing trains, many sided with them, believing that the evil railroad was getting what it deserved. But law enforcement authorities, railroad officials and the Wells, Fargo Company saw train robbery differently, and for the next several years, the outlaw team of Evans and Sontag had targets on their backs.

Chris Evans was born in 1847 in the little Canadian settlement of Bell's Corner in Nepean Township near Ottawa. It is not clear when he came to the United States, but according to his daughter, Eva, he ran away from home at sixteen, crossed the border into Buffalo, New York, and enlisted in the Union army.[119] Eventually, he made his way to California and then to Tulare County, where he worked as a teamster in the lumber mills in the nearby Sierra. In 1874, Evans married Mary Jane "Molly" Byrd, and the couple made their home in Visalia. His early years in Tulare County were generally respectable; however, he did have at least one brush with the law. In 1875, he was working as a teamster and had a confrontation with a coworker. He ended up beating the man savagely with a piece of iron and paid a fine for his violent act.[120]

John Sontag was born to Jacob and Maria Contant of Mankato, Minnesota, in 1861, and his brother, George, was born in 1864. In

1866, the boys' father was killed in a construction accident, and a year later, their mother remarried Mathias Sontag, a wealthy Mankato businessman. John assumed the last name of his stepfather, but George kept his biological father's last name.[121] George had some run-ins with the law as a young man and, as a result, spent some time in the Minnesota State Reform School and, later, the Nebraska State Prison.

John Sontag came to California in about 1878, and after working at a variety of jobs, he was hired by the Southern Pacific Railroad Company as a brakeman.[122] In about 1887, he transferred to Tulare County. After a short time, he was involved in an accident in which he was crushed between two railroad cars and badly injured. He survived his injury

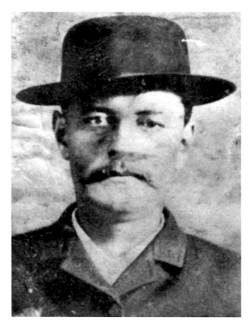

John Sontag was born in Minnesota. He came to California and teamed up with Chris Evans, and the two robbed trains, murdering in the process. Sontag's violence would come back to him when he was on the receiving end of the shootout at Stone Corral, image circa 1892. *Annie R. Mitchell History Room, Tulare County Library, Visalia, California.*

but was unable to keep his job. According to him, the company would not help him find other employment, and this angered Sontag and left him with a lasting resentment toward his former employer.

One day, Chris Evans was in the town of Tulare talking with a group of men, including John Sontag. The injured man complained to Evans about the treatment he received from the railroad, and both shared the scorn they felt over the Mussel Slough incident a few years earlier. Evans offered Sontag a job on his farm just outside Visalia, and Sontag accepted the offer.[123]

In about 1890, the Evans family, including John Sontag, moved to Modesto, where Evans leased a livery stable. A short time later, the stable burned down, destroying the building and its contents. He had no insurance, so the financially ruined Evans family and John Sontag returned to Visalia.[124]

Between 1889 and 1892, train robbery became a problem in Tulare County and the San Joaquin Valley. The Southern Pacific made regular

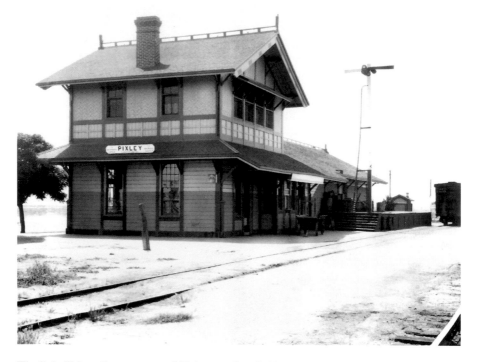

The little Tulare County town of Pixley was founded in 1886 by Frank Pixley, the editor of the *San Francisco Argonaut*. Because of his influence with the Southern Pacific, a depot was built. Just three years after the town got its start, a train was robbed nearby, and two men lost their lives, image circa 1910. *Tulare County Museum.*

runs up and down the valley, often carrying large amounts of money in the express car, making them attractive targets.

On February 22, 1889, as southbound passenger train no. 17 arrived in Pixley, two armed men jumped on board. When the train was about two miles south of this little southern Tulare County town, the two masked men approached engineer Peter Bollenger and fireman C.G. Elder and ordered them to stop the train. When the train stopped, the bandits escorted the two trainmen back to the express car. Two passengers, Charles Gobart and Ed Bentley, who was the deputy constable of Delano, sensed that there was a problem and got off the train to investigate. The nervous bandits spotted them, and one fired a shotgun blast into Gobart, killing him instantly. A second blast mortally wounded Constable Bentley. J.R. Kelly, the express car employee, heard the gunfire and locked himself inside. The outlaws ordered him to open the door, but he refused. They set off an explosive charge near

the door that rocked the car, but the door remained secure. The two then ordered Kelly to open the door, threatening to kill Bollenger and Elder if he refused. The expressman reluctantly opened the door, and one of the bandits entered while the other guarded the hostages. The unidentified masked men made off with loot valued at about $3,000.[125] A reward of $2,000 each was placed on the heads of the two robbers.[126]

The next robbery occurred about a year later near Goshen, the small railroad town just west of Visalia. At about 4:00 a.m. on January 22, 1890, southbound train no. 19 was stopped by two armed masked men who had secretly slipped onto the train. They ordered fireman G.W. Lovejoy and engineer S.H. DePue to stop about two miles south of Goshen, and both men were escorted at gunpoint to the express car. The robbers demanded the door be opened and threatened to kill their hostages. The expressman opened the door, and one robber began gathering the money. As the other robber was guarding the train employees, an unfortunate hobo named Christiansen, who had been riding under the express car, unexpectedly emerged, curious about all the commotion. The startled robber fired a single shotgun blast at Christiansen, killing him instantly. The two robbers then fled, reportedly taking thousands of dollars. Their descriptions and their method of operation matched the Pixley train robbery from the previous year. A posse soon trailed the unknown bandits to Visalia, and the robbery and murder investigation continued.

The following year, the little town of Alila (now called Earlimart) in southern Tulare County became the scene of an attempted train robbery. At about 8:00 p.m. on February 6, 1891, Southern Pacific train no. 17 was stopped by two bandits, who attempted to steal from the express car. They were unsuccessful, but fireman George Radcliffe was killed in the process. Lawmen trailed the suspects to the home of Bill Dalton near Paso Robles in San Luis Obispo County. Bill (and later his brother, Gratton) was eventually arrested for the attempted Alila train heist and held at the Tulare County Jail.

While the two Dalton brothers were in custody, another Southern Pacific train became the target of robbers. This time, on the evening of September 3, 1891, southbound train no. 19 was held up near Ceres in Stanislaus County. As in the Goshen and Pixley crimes, the two masked men escorted the engineer and fireman back to the express car. When refused admittance, the bandits placed a "giant powder bomb" near the express car door and blew it open.[127] Leonard "Len" Harris, a Southern Pacific detective, happened to be on the train, heard the explosion and cautiously walked toward the

express car. When he spotted the robbers, he fired his revolver at them, but neither was hit. One of the robbers returned fire, seriously wounding the train detective. The outlaws fled with the loot.

About the same time, similar train robberies were occurring in the Midwest. In November 1891 near Racine, Wisconsin, and in July 1892 near Kasota, Minnesota, trains were attacked using similar techniques as in the California robberies. Law enforcement authorities in Mankato, a neighboring town to Kasota, began a search for the robbers. Their investigation led them to Mankato resident George Contant, a man who appeared to have plenty of money but no job. Charles Naughton, a stranger to the area and friend of Contant, also became a suspect in the Kasota incident. Authorities later learned that Naughton was an alias used by Chris Evans of Visalia. Contant and Naughton knew that they were being watched, so they avoided each other. Contant secretly left a note for Naughton telling him to meet in California.[128] Both men independently traveled back to Tulare County, much of the time being watched by authorities.

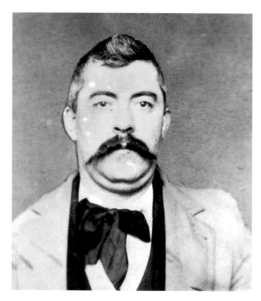

When George Contant arrived back in California, he met his brother, John Sontag, and the two began planning a train heist in Collis (now called Kerman). Chris Evans joined in the scheme, and on the evening of August 3, 1892, Sontag, Contant and Evans boarded train no. 17. They ordered engineer Al Phipps and fireman Bill Lewis to stop the train. As before, the express car employee refused to open the door, so the robbers blew it open. The outlaws carried off several sacks of money, some of which were Peruvian coins.

George Contant, the brother of John Sontag, was convicted for his involvement in the August 3, 1892 Collis train robbery and sentenced to life in Folsom State Prison. While there, he confessed to the train robbery and implicated Evans and his brother at the same time. Contant eventually testified against Chris Evans. When and where Contant died remains a mystery, image circa 1892. *Annie R. Mitchell History Room, Tulare County Library, Visalia, California.*

The men traveled to Visalia and buried the bags of money on Evans's property. Soon after, Contant circulated around Visalia's saloons and began talking—too much for his own

good. Local authorities quickly learned that he had considerable knowledge about the details connected to the Collis robbery. They arrested him for involvement in the crime, and eventually he was sentenced to life in Folsom State Prison.

At about noon on August 5, 1892, two days after the Collis robbery, Tulare County deputy sheriff George Witty and Southern Pacific Railroad detective Will Smith went to the Chris Evans house to talk to John Sontag as part of their investigation. The lawmen were immediately confronted and challenged by the armed Evans and Sontag. The lawmen made a hasty retreat as gunfire erupted, and both Witty and Smith were wounded. Evans and Sontag quickly fled Visalia with lawmen and a posse in pursuit.

Tulare County deputy sheriff Oscar Beaver, who normally worked in Lemoore, was called to Visalia and assigned to watch the Evans home in case the men returned. In the early morning hours of August 6, 1892, while Beaver was hiding on the ditch bank near the house, he saw two men preparing a buggy. Beaver stood up and in the darkness yelled, "Halt. Who are you?"[129] The two men responded with their shotguns. The lawman was hit and died a short time later. Evans and Sontag were on the run.

The Evans property, located a short distance northwest of Visalia, included a house and barn. Here Evans and Sontag fired on Tulare County deputy sheriff Oscar Beaver, killing him. Lawmen found the buried coins here as well, image circa 1893. *Tulare County Museum.*

While law enforcement officers continued to hunt for the pair of killers, they also looked for evidence connecting them to the other earlier train robberies. When Wells, Fargo detectives James Hume and John Thacker received information that the bags of coins from the Collis robbery were buried on the Evans property, they searched and uncovered two fifty-pound sacks of coins, strong evidence that the two were the train robbers.

While fugitives Evans and Sontag hid in the Sierra Nevada mountains, they sometimes received help from sympathetic mountain folks. On September 6, 1892, a reward of $10,000 was offered jointly by the Southern Pacific Railroad Company and the Wells, Fargo Company for their arrests. On September 13, a posse led by Southern Pacific detective Vic Wilson stopped at the James Young cabin on Pine Ridge near Sampson Flat in Fresno County. Young wasn't home, but unbeknownst to the posse, Evans and Sontag were hiding inside. Wilson and fellow posse member Andrew McGinnis approached the cabin, unaware of the danger they were facing. As the two officers neared the porch, Evans and Sontag burst out of the cabin firing their shotguns at the approaching lawmen. Both Wilson and McGinnis were killed, and the bandits slipped away.

It was from this cabin near Stone Corral that U.S. Marshal Gard and his posse surprised Evans and Sontag as they made their way from their mountain hideout to Visalia. This ambush marked the beginning of the end for this outlaw team, image circa 1893. *Annie R. Mitchell History Room, Tulare County Library, Visalia, California.*

For the next nine months, Evans and Sontag attracted considerable local and statewide attention. Lawmen and bounty hunters were drawn to Tulare and Fresno Counties, all trying to capture the outlaws and earn the reward money.

On May 31, 1893, U.S. Marshal George Gard received a telegram from Wells, Fargo detective John Thacker asking for a meeting. The two men met and formulated a plan to stop the outlaws. Gard shared his motivation to become involved with Thacker, saying, "The bandits had run about long enough and it was a duty I owed to the people to try and assist in their capture."[130]

On June 11, 1893, a special posse led by Marshal Gard secretly hid in a cabin near a rock-walled hog enclosure known as "Stone Corral." They had received word that the outlaws were coming down from the mountains and returning to Visalia. The posse quietly watched the trail. Just before sundown, they saw two men coming and, using a telescope, identified them

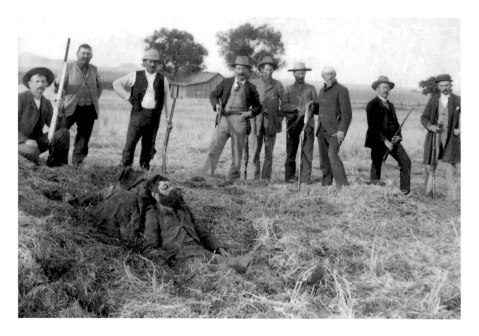

U.S. Marshal Gard's posse poses behind the mortally wounded John Sontag the morning after the June 11, 1893 shootout. Chris Evans was badly wounded but was able to crawl off during the darkness. He was later captured. Sontag died from his injuries about three weeks later. The posse consisted of U.S. Marshal George Gard (third from the right) and Deputy Marshals Tom Burns (fourth from right), Hiram Rapelje (second from left) and Fred Jackson, who was wounded and is not shown. The remainder of this group came to the scene after the shooting. *Tulare County Museum.*

as outlaws Evans and Sontag. When the two were about one hundred yards from the cabin, Evans saw a member of the posse and fired at him. The lawmen immediately returned fire, and the resulting shootout lasted an hour, with about 140 rounds exchanged. The two men were caught in an open field, so they were forced to burrow into a nearby straw pile to escape the fusillade. The following morning, the posse cautiously approached the straw pile. They found Sontag semiconscious and badly injured with multiple gunshots, but Evans was gone. Sontag was loaded into a wagon and brought to the county jail in Visalia where he received medical attention.

Later, authorities learned that on the evening of the shootout, under the cover of darkness, the wounded Evans crawled to Elijah H. Perkins's home in Wilcox Canyon. When the outlaw was discovered by the Perkins family, they notified Tulare County undersheriff William Hall, who arrested Evans and brought him to the county jail. Dr. Harley Mathewson was brought in to treat the serious injuries to Evans's right eye, back, right wrist and left forearm. The doctor had to amputate part of his left arm below the elbow and eventually fitted him with an artificial arm.

The shootout at Stone Corral was widely reported and was especially big news in Visalia. Almost immediately, local law enforcement officials heard rumors of possible vigilante action against the two wounded men. Fearing a

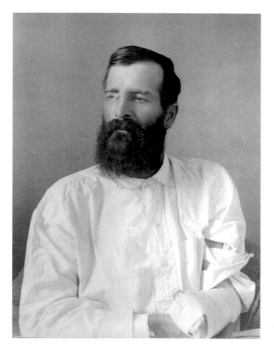

Chris Evans sustained major injuries in the 1893 Stone Corral shootout, including the loss of his right eye and the loss of part of his left arm. The ambush was a setback for the outlaw, but soon he was on the run again. *Annie R. Mitchell History Room, Tulare County Library, Visalia, California.*

lynching, authorities quickly moved them to the Fresno County Jail, where the thirty-seven-year-old Sontag died from his injuries on July 3, 1893. Evans slowly began to recover.

While Evans was awaiting trial, Molly and Eva, his wife and daughter, asked his permission for them to star in a stage drama about the lives of Christopher Evans and John Sontag. They had been approached by R.C. White, a San Francisco stage actor, and felt it was an opportunity for the Evans family to tell their side of the story and earn money for his defense. He agreed, and Molly and Eva played themselves on stages throughout California, but the play was not welcome in Visalia.

In November 1893, Evans's trial began for the murders of Vic Wilson and Andrew McGinnis at Young's cabin. The prosecution brought in George Contact as a surprise witness to testify against Evans. While in state prison, George Contant had given a full confession to Wells, Fargo detective Hume about the robberies and murders, implicating Evans. Evans was found guilty of murder and sentenced to life in state prison.

With a life sentence for Chris Evans and the death of John Sontag, it appeared as if the days of running were over. But that was not the case—Evans had a surprise for everyone. While awaiting sentencing, Evans remained in the Fresno County Jail. On December 28, 1893, a young waiter named Ed Morrell, who worked at the Quinby House restaurant, came to deliver a meal to the prisoner. The food was given to Evans, and when the jailor returned a short time later, he was confronted by an armed Evans and Morrell. The two men escorted the jailor out of the building and into the street. After walking a short distance, the trio met Fresno city marshal John D. Morgan. There was a struggle, and Morgan was shot. Morrell and Evans commandeered a horse and cart, and they took off to the mountains, where they remained in hiding. On February 6, 1894, a posse discovered one of the outlaws' camps and surprised the two men. The escapees grabbed their rifles and quickly left camp, but in his haste, Evans left his artificial arm behind.[131]

In an attempt to entice the pair back to Visalia, law enforcement officials planted a fabricated story with an outlaw confidant that Evans's son was seriously ill. Evans and Morrell got the message and returned to town. When Evans saw that his son was not sick, he knew that he had been tricked, but he wasn't sure by whom. Jonas V. Brighton and his wife had been friends and neighbors to the Evans family since May 1893 and had cared for the Evans children. So when Evans and Morrell were in Visalia checking on Evans's son, they asked Brighton to pick up some medicine and a quart of whiskey. Unknown to Evans, Brighton had been an undercover deputy U.S. marshal

Jonas V. Brighton was an undercover deputy U.S. marshal who befriended the Evans family in order to get information about the two outlaws. He and his wife lived near the Evans property, did chores for them and took care of the Evans children while passing along important secrets to the authorities. This line drawing of Brighton appeared in the *San Francisco Examiner* on February 25, 1894.

the entire time he had been a neighbor. So when Brighton picked up the items Evans requested, he also alerted Tulare County sheriff Eugene Kay.

In the early morning hours of February 19, 1894, Sheriff Kay and his fifty-man posse surrounded the Evans home. At about 10:00 a.m., the sheriff had a note delivered to Evans encouraging him to surrender. The timing was right. Evans was tired of running, so both Evans and Morrell gave up.

Sheriff Kay and Undersheriff Hall took them into custody and delivered them to the county jail. Soon the sheriff heard talk of a lynching again, so he quickly made arrangements to get Evans and Morrell to the Fresno County Jail. Sheriff Kay, Fresno County sheriff Jay Scott and Tulare County deputy sheriff Witty quietly loaded the two men onto a wagon and headed to Goshen. The prisoner relocation plan was discovered, and on their way, a large crowd began to follow. The thought of being lynched made the two prisoners nervous, and Morrell looked back frequently for the pursuers. He even asked to have his handcuffs removed just in case he needed to defend himself.[132] The lawmen and fugitives arrived safely at the Fresno County Jail. Now Evans was back in court again, and on February 21, 1894, he finally began his life sentence in Folsom Prison. Morrell was eventually tried and convicted and received a life sentence for robbery and aiding Evans in his jail escape.

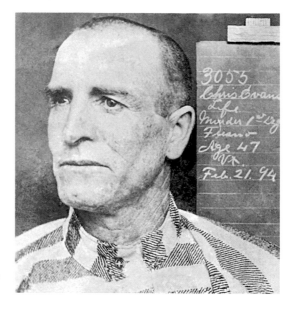

Chris Evans, age forty-seven, convict no. 3055, entered Folsom State Prison on February 21, 1894, to begin his life sentence. He asked to be sent to San Quentin rather than Folsom because George Contant was there, but his request was denied. Evans was paroled in 1911. *Tulare County Museum.*

Evans was paroled to live with one of his daughters in Portland, Oregon. In 1916, Evans visited his daughter Eva in the Los Angeles area, and this photograph is the last known image of the old outlaw. The seventy-year-old man died on February 9, 1917, and was buried in Portland, image circa 1916. *Annie R. Mitchell History Room, Tulare County Library, Visalia, California.*

While at Folsom, Evans was well behaved, and on May 1, 1911, he was paroled to live with his daughter in Oregon. He lived a quiet life and died on February 10, 1917, in Portland, where he was buried. Upon his death, the local Visalia newspaper quoted the *Portland Journal*: "Chris Evans, leader of the famous Evans and Sontag outlaw band in Central California, notably in Tulare County, 20 years ago, died at a local hospital tonight. He was 70 years of age."[133]

The death of the former train robber and killer marked the final chapter in the life and times of Visalia's notorious crime duo.

Keener and Dowdle

Stage Careers that Went Bad

The news of John Keener's death and William Dowdle's capture came as a surprise to many in Visalia. Keener and Dowdle were both members of highly respected pioneer Visalia families, and reports of death and capture in a botched stagecoach holdup were hard to believe. As details of the tragic incident emerged, it was clear that Tulare County had been hit again with "unenviable notoriety."[134]

John Levi Keener was born in Missouri in 1860 to James and Eliza Keener. James was a cattleman and early on moved his operation to Tulare County. He was industrious and prospered, acquiring considerable land. In fact, at one point, the Keener family paid more property taxes than any other landowner in the county. They were generous people, providing the local Native Americans with food and giving land in town for an early school.[135] In 1864, James and Eliza died, and their children, including John, were sent to live with relatives.

One of John's early childhood friends was William E. Dowdle, who was born in 1863 in Visalia. His family had been part of the Keener wagon train heading west, and they were also in the cattle business. In about 1877, probably due to California's new restrictive cattle legislation, the Dowdle family moved to Tucson in the Arizona Territory. The family was prominent, successful and wealthy. William's brother, Harry, became county recorder for Pima County, and one of his sisters married a banker from Madera, California.

Apparently, John Keener also lived for a period of time in Arizona, where he "got into some trouble that came near resulting in his incarceration

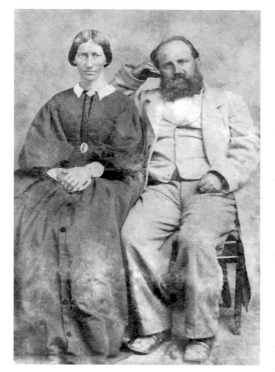

James and Eliza Keener were early arrivals to Tulare County, reportedly bringing the first herd of cattle into the county in the early 1850s. The family acquired considerable property. John, one of their sons, associated with the wrong crowd and chose stage robbery as a career. It was a bad decision that cost him his life, image circa 1860. *Author's collection.*

in the penitentiary." The Dowdles helped Keener out of his legal bind, and he was able to avoid punishment.[136] Keener came back to Visalia, began gambling heavily and lost sizeable amounts of money on a regular basis.

In early January 1894, William Dowdle also returned to Visalia from Arizona using the assumed name of H. Kirkland. He had been away for about seventeen years, but several Visalians still recognized him. When confronted, he admitted that he had assumed an alias because he had gotten into some trouble back in Arizona and didn't want to be identified. Later, it was learned that he was wanted in the Arizona Territory for stage robbery and had a reward of $500 on his head.[137] Dowdle and Keener hung around together, and despite having no obvious source of income, they frequented saloons and gambling halls, flashing money freely.

In the first few months of 1894, apparently unbeknownst to many, the two made regular trips north to the gold country of Calaveras County. It was during these visits that the two held up stagecoaches. They had mixed success with the robberies but managed to learn from each crime and refine their approach.[138]

The local Visalia newspaper initially did not connect Keener and Dowdle to the string of stage robberies in Calaveras County. The newspaper did report, however, that on April 15, 1894, the two told friends that they were leaving town to work at the Red Rock Mine in Kern County.[139] But instead of heading south, the two men traveled

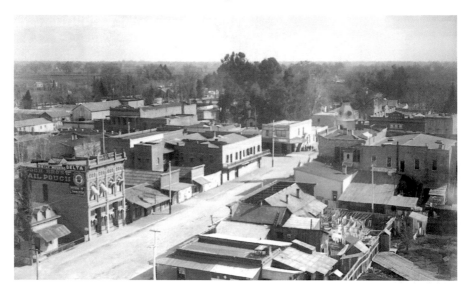

Visalia in the 1890s offered Keener and Dowdle many choices for drinking, gambling and associating with the ladies of the evening. Taken from the cupola atop the Tulare County Courthouse and looking south on Church Street, this 1895 photograph shows the *Visalia Delta* newspaper building on the left, and in the center is the Visalia House, a saloon and lodging establishment. *Author's collection.*

north. They spent some time in Sonora, where they "made a living by gambling around the saloons. Keener was anything but a good gambler, although he was passionately fond of cards. The two men were always together and people called them the two 'dromios.'"[140] Eventually, another Visalian named Amos Bierer joined them.

The three men prospected as they worked their way to Angels Camp, but they had no luck finding the precious metal. According to Bierer, they considered robbing a store but decided against it. In later statements, Bierer said that Keener eventually suggested stage robbery as a source of income.[141] The three agreed and began preparations. Keener ordered Bierer and Dowdle to purchase a donkey and provisions. They followed his direction and then set up camp on the Stanislaus River. Keener met them at the camp on May 10, and they continued to work on plans for the robbery.

The next morning, the three heavily armed men abandoned their camp and set up a new one near Vallecito by Wermouth's Ranch. They remained there for about a week as Bierer gathered details about local treasure shipments. The information he learned concerned him, and he shared it with his partners. Bierer told them that because of the number of recent

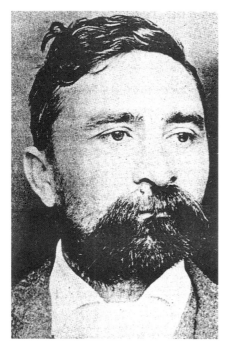

William Dowdle, Keener's partner in the failed stagecoach holdup near Angels Camp, was convicted and sentenced to fourteen years in Folsom State Prison. He began his sentence in 1894, and in 1902, he was paroled. After his release, Dowdle moved to Arizona, image circa 1894. *Tulare County Museum.*

robberies, the stages were going to be guarded more closely. According to Bierer, Keener said that he was not concerned and would kill any guard who got in his way. This bloodthirsty attitude bothered the twenty-five-year-old Bierer, and he told his partners that he did not want to kill and withdrew from the scheme. He left the outlaw camp on May 18.

The next day, Keener and Dowdle made their way to a quiet area along the route of the Angels-Milton stage by Poole's Ranch, about twelve miles from Milton. One of the robbers positioned himself on one side of the road, with the other on the opposite side. As the stage approached, loaded with $15,000 worth of gold bullion, Keener stood and presented himself with gun in hand. Before Keener could shout any orders, Wells, Fargo stage guard William Hendricks let loose at Keener with a shotgun. Keener took the full impact, and as he began to fall, Hendricks fired another blast. The jolt from the second shot caused Keener's cocked shotgun to discharge harmlessly into the air. The commotion caused the stage team to bolt, and Dowdle fired at the runaway stage, wounding passengers T.T. Hume of Murphys and Miss Bonny of Almaden. Stage driver Fred Wesson gained control and brought the team safely to Poole's Ranch.

Back at the scene of the robbery attempt, Dowdle checked on Keener. He found his partner barely conscious and riddled with buckshot from head to foot. According to Dowdle, Keener pleaded with him to take his pistol and shoot him to end his life and stop his misery. Dowdle refused his partner's request, and Keener demanded that he leave. He left, and a short time later, Dowdle heard a single shot. Keener had taken his own life.[142] But some disputed the suicide story because only buckshot wounds were found on the dead man's body.[143]

As the lawmen began the investigation, they knew that at least one other robber was on the loose, so the hunt began. They learned that Keener and Dowdle had been seen leaving Visalia together in April, so suspicion now focused on Dowdle as the second robber. On the evening of May 28, the hunted man was found under strange circumstances. A Visalia newspaper quoted the account of his discovery and arrest, as reported in the *Stockton Independent* newspaper:

> *Monday night one of the farm hands on Ed Moore's ranch, about three miles east of Copperopolis, had business behind an unused shed searching for a shovel. He did not find the shovel but he was astonished to discover a man lying close up to the walls of the shed moaning and sobbing as if his heart would break. The farm hand put his hand on the fellow's shoulder and inquired what ailed him.*
>
> *Instead of replying the fellow simply moaned in a slightly more agonizing manner. The ranch man became convinced that the fellow was either sick or crazy, or perhaps both. By a great deal of coaxing he managed to get the sick man to follow him to the house.*
>
> *Here the man was placed in a chair and some food was placed before him. He seemed to be in a sort of delirium and would not touch the food. When asked if he was sick, he simply rolled his eyes in a listless sort of a way and would give no intelligible reply.*
>
> *The town constable was notified of the discovery of the queer man and came to see him. The moment he cast his eyes on him he said that the fellow was wanted for the stage robbery. He placed him formally under arrest... He was taken to San Andreas and lodged in the county jail. The officers say the fellow is playing possum, so to speak, but the people of Copperopolis think the man was in the last stage of starvation when found and that his mental negativity is the result of exposure and weakness.*[144]

No one seems to know why Dowdle was in such a condition, but he did recover, and Amos Bierer, the man involved in the robbery planning, was arrested near Angels Camp. Both Dowdle and Bierer confessed to their roles in the ill-fated stage robbery and were sentenced to fourteen years in Folsom Prison. Keener, of course, never made it back to Visalia, and his body lies in Calaveras County. The boys from Visalia failed at stagecoach robbery but were successful in adding to the tarnished reputation of Tulare County.

He Was Known as
Bloody Morris

William Gouverneur Morris had an impressive pedigree. His great-grandfather had been a general in the Revolutionary War and a signer of the Declaration of Independence. Another relative had a part in writing the U.S. Constitution, and his father was a West Point graduate with a distinguished military record.

Morris was born in Brooklyn, New York, in December 1832, and in 1855, with a Harvard law degree in hand, he came to San Francisco ready to begin his law career. In 1857, he moved his practice to Visalia, specializing in the collection of debts and claims.[145] The governor appointed him to the prestigious position of notary public. He became a law partner with J.W. Freeman and eventually teamed up with pioneer Visalia lawyer Samuel C. Brown. Morris was politically active and well connected and corresponded regularly with national and state politicians, so while in Visalia, he naturally immersed himself in local politics.

In the summer of 1858, Morris became entangled in a bizarre, violent and complicated legal case. It seems that J.D. Stapleford deeded his real property, valued at about $40,000, to his uncle, William C. Deputy, possibly in an effort to shield it from creditors. His uncle managed the property, and then after a time, the nephew asked for the property back. Deputy refused, and his nephew filed fraud charges against him. Deputy was arrested and placed in the Tulare County Jail, a wooden structure with a brick floor and a large oak post solidly planted in the center. He was chained to the post.[146]

Tulare County sheriff W.G. Poindexter heard rumors of a plan to forcibly remove the man from jail, so he placed Frank Warren and Ed Reynolds at the

county lockup for additional security. Late in the evening of July 28, 1858, a vigilante mob, many say led by Morris, stormed the jail, overpowered the guards and entered. They asked Deputy if he would relinquish the property in question to Stapleford, and he said that he would not. The men removed the chain holding him to the post and escorted Deputy to the north edge of town. They tied one end of a rope around his neck, threw the other end over a tree limb and raised Deputy into the air by his neck. When he was almost unconscious, he was lowered to the ground and asked again if he would sign over the disputed property. He still refused, so the men pulled him up once more. This time, according to the witnesses, Morris whipped him for good measure as he dangled in the

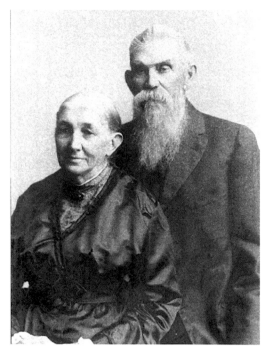

Ed Reynolds was one of the first pioneers to arrive in Visalia by wagon train in 1852. In 1858, he was part of the security detail at the county jail to protect a prisoner. Reynolds later recalled that the mob, led by Morris, forcibly removed William Deputy from the jail and coerced the man into signing legal papers. Shown here is Ed Reynolds and his wife, Electa, at their fiftieth wedding anniversary in 1916. *Author's collection.*

air. Delirious from pain, the man was lowered and finally agreed to sign the property documents. Deputy was led back to the jail by his tormentors. He signed the papers, and they were promptly notarized by Morris.

On July 30, a complaint was issued for the arrest of the members of the mob. Morris was arrested for his lead role in the violent act. He pleaded not guilty and requested a jury trial. It was quick, and after fifteen minutes of deliberation, the jury found him guilty. Justice of the Peace C.G. Sayle ordered Morris to pay a fine of $500 or serve a six-month sentence in the county jail. There is no evidence that Morris ever paid the fine or served time.

Many in Visalia were in an uproar over the Deputy incident. On August 2, 1858, nearly fifty prominent citizens petitioned California governor John B. Weller to have Morris removed as a notary. In the petition, the citizens

outlined their main reason for the request, writing in part, "Morris did there and then with his own hands, flog the said Wm. C. Deputy on his bare back till it was inhumanely lacerated and compelled him while writhing in torture to consent to sign a deed."[147] Morris somehow made it through the Deputy affair, but for many he was clearly a branded man.

In the years leading up to the Civil War, Visalia was a politically active and contentious town. Most residents came from the South or at least supported the Southern position, and they were vocal about their views. Emotions ran high in this divided town. As the rhetoric between the two sides escalated, Morris, representing the Union side, and John Shannon, the local newspaperman supportive of the South, were at opposite sides of the political spectrum.

Shannon came to California from Ohio in 1849 and eventually bought the *Calaveras Chronicle* newspaper in Mokelumne Hill in California's gold country. In July 1859, Shannon sold the *Chronicle* and purchased the *Tulare County Record and Fresno Examiner*, Visalia's first newspaper. In October, he changed the name to the *Visalia Weekly Delta*. Shannon, a states' rights man, took every opportunity to editorially attack those who disagreed with him. Morris on the other hand, was a President Lincoln man, and he, too, was not shy about sharing his position. As the Civil War became a reality, Visalia was on edge, with Shannon and Morris poised to battle.

In September 1860, a newspaper called the *Visalia Sun* appeared in town, with its masthead proudly proclaiming, "It Shines for All." Shannon, through the *Delta*, graciously acknowledged his competitor and, like a good neighbor, welcomed it to the community.

Even though Morris was not officially part of the *Sun*, he was believed to be editorially involved, and before long, the *Sun*'s political position was clear to everyone, including Shannon. It supported the Union and was an organ of the Republican Party.[148] The initial goodwill between the two newspapers ended quickly, and soon the rivals were at each other's throats. Editorially, words were exchanged between the two men, and it became personal. Morris was angered by the character attacks, and on September 15, he gave Shannon a note challenging him to a duel: "I therefore demand of you preemptory satisfaction, usually accorded for one gentleman to another." The same day, Shannon consented to the challenge, replying, "Your offer to fight is accepted."[149] The duel never took place, but the scene was set for a violent confrontation.

On November 3 the *Delta* took another editorial shot at the *Sun*, mocking and insulting the newspaper, saying, "It [the *Visalia Sun*] shines for all, yes in

like manner does decayed fish in a dark night. It shines and stinks and shines to stink again."[150] The rhetoric between the men reached a boiling point.

On November 15, 1860, at 3:00 p.m., the angry John Shannon confronted the equally angry Morris at attorney Robert Gill's office. Shannon, the taller of the two men, stood in the doorway with a "large-sized revolver" in hand and asked, "Morris are you armed?" Morris ran at Shannon, struggling with the man. As the two fought, Shannon's firearm discharged, causing a deafening explosion. No one was hit, but Shannon then began hitting Morris over the head with his pistol. The bleeding Morris collapsed on the floor unconscious.

Shannon left Gill's office, and soon Morris regained consciousness. Although stunned and dizzy, he stood up and asked,

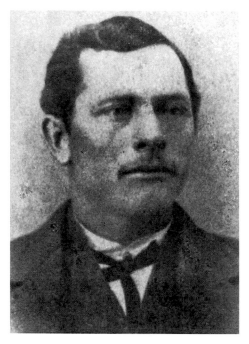

John Shannon, a veteran newspaperman, had strong political differences with William G. Morris, and the harsh words between the two men escalated to a deadly shootout on the streets of Visalia in 1860. Reportedly, this is the last known photograph of Shannon before his death. Well known in journalism circles, his death made news throughout California, image circa 1859. *Tulare County Museum.*

"Where is he?" He picked up his large navy Colt revolver and went out the back door, looking for a clear shot at his assailant. Morris caught a glimpse of the attacker and fired two shots. Shannon returned fire. Morris then exited the front of the building and fired again at his target. This time, Shannon grabbed his abdomen and staggered into his office. Dr. W.A. Russell was called to treat his single bullet wound to the stomach just below the navel. Shannon died at 4:30 p.m. on November 15.[151]

The next day, a coroner's inquest was held, and the twelve-man jury identified Morris as the shooter. Although the verdict was not unanimous, the members found that his actions were justifiable under the circumstances. Despite the jury's majority ruling, Morris was ordered to court as a defendant in the homicide. On November 17, Morris stood before Judge

Owen. After hearing a full day of testimony, the judge ruled that the killing was justifiable homicide.[152]

Many in Visalia mourned the death of the forty-three-year-old Shannon. Even though he was relatively new to Visalia, he had been a well-respected journalist. The twenty-eight-year-old Morris had his supporters, too, but was feeling community pressure to leave town. This latest incident and the lingering black mark from the Deputy affair were taking its toll. He ended his law practice and left town.

Morris joined the California Volunteers in February 1861 serving as a first lieutenant. Ironically, in late 1862, he was even assigned for a short time to the cavalry unit at Visalia's Camp Babbitt. Later, he served in the regular army as a captain and mustered out of the military in February 1866 as a brevet major.

After leaving military service, he purchased property in Napa County and, by 1868, was again considering public service. In December of that year, John Bidwell, an early California politician and army general, wrote a letter to president-elect Ulysses S. Grant recommending Major Morris for the position of U.S. marshal for California.[153] In August 1869, Morris received the appointment. However, his confirmation by the U.S. Senate was put in doubt when the Senate received an unsigned letter questioning his suitability, pointing out his problems in Visalia a decade earlier.

Morris responded with his own letter, saying that the anonymous writer was lying about his actions in Visalia. Morris rationalized his conduct, pointing out that the town was "on the Indian frontier, remote from civilization," and he further explained that the people of Visalia at the time were "wild lawless men."[154] Morris's friends and colleagues began a letter-writing campaign in support of his confirmation as U.S. marshal. It was successful, and he was confirmed by the Senate on April 5, 1870. He served as U.S. marshal until 1873, when he left office, apparently not by choice. A Visalia newspaper reported the news: "President Grant has removed Wm. Gouverneur Morris from the position of U.S. Marshal from the State of California, and nominated one Marcellus for the position. Good for Grant in one thing at least. Small favors thankfully received."[155]

Morris continued in government, serving as a special agent in the U.S. Treasury Department, working in the Pacific Northwest and Alaska. Eventually, he became the U.S. collector of customs for the district of Alaska.

Even though his acts of violence seemed to have subsided after leaving Visalia, Morris's sharp tongue did not. Complaints about him were common. One person called him vulgar, profane, lazy and overbearing.[156] Another

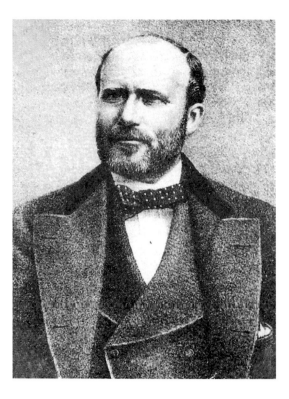

William G. Morris was a strong Union man who had difficulty tolerating other political opinions. As a result, he and Shannon were destined for a battle. Morris challenged his archenemy to a duel, but the so-called gentlemen's approach to resolving differences never happened. Instead, they had a bloody street fight. Morris went on to serve in important government positions, including U.S. marshal for California, image circa 1880. *Tulare County Museum.*

detractor claimed that Morris was a man who "too often acts from passion and is lacking in judgment."[157] And yet another claimed that Morris was a drunk who had "an overbearing exercise of authority."[158]

In the latter part of 1883, Morris became seriously ill. On January 31, 1884, William G. Morris, U.S. collector of customs, died of pneumonia in Sitka, Alaska, and was buried there. When the press reported on the fifty-two-year-old man's death, it called him an "old and prominent politician of California,"[159] but much of Tulare County remembered this former Visalia ruffian as "Bloody Morris."[160]

John Schipe

The Most Dangerous Man on the Pacific Coast

B orn in Germany in about 1836, John Schipe made his way to California in 1859 by way of Pennsylvania. He was a strong, handsome and some say barbaric man who stood over six feet tall and weighed 220 pounds. He seemed to fit the wild and primitive land of the Golden State, always armed with a rifle, two Colt six-shooters and a knife. He had a pleasant personality when sober, but when he was drunk, he became nasty—a condition that ultimately precipitated his demise on the streets of Visalia.

This outdoorsman was a miner, trapper, sluice robber and hunter of both man and beast. In May 1859, Schipe (sometimes spelled as Shipe) was mining on the east branch of the Feather River at the small settlement of Twelve Mile Bar in Plumas County. He got into a fight and was stabbed by a man known as Boston Jack. A few days later, Schipe found his assailant and took a shot at him but missed. A posse was organized to hunt Schipe down, and the men cornered him in a ravine near the river. He jumped down a steep embankment into the river and escaped as the posse opened fire on him, unloading thirty-five rounds.[161]

During Schipe's time in California, relations were strained between the newly arrived white settlers and the native people of the state. Agreements were made and broken frequently, and hostilities were often the result. Military garrisons were established throughout California to maintain law and order.

In 1863, likely on the run from Plumas County, Schipe made it to the southern Sierra Nevada, where he teamed up with William Henderson, Frank Whitson and Lyman Martin. Together the four men massacred

eleven Indians—a group reportedly on its way to surrender to army authorities at Camp Independence. Whitson was arrested for the attack, but Schipe got away.[162]

Because of this incident and others, Schipe earned a reputation for his savagery toward native people. Well-known journalist and Tulare County resident James W.A. Wright wrote, "So long as Shipe, the noted Indian hunter and trapper, lived—he helped to keep up this guerrilla warfare by killing or trying to kill every one of these Indians he met. Squads of soldiers were frequently sent to arrest him, but were never successful. He knew the mountains too well."[163]

By August 1865, Schipe had settled near what was to become the town of Dunlap in southern Fresno County. One day, he, his friend Tom Jeffers and another man named Sutterfield were drinking at Peyton's store on the Kings River. While under the influence, Sutterfield and Schipe began to argue over politics, and the words turned physical. Schipe was getting the best of the other man, and as he sensed that the fight was over, he gave the downed man one last kick. As Schipe stepped back, Sutterfield rose to his feet cursing. Jeffers warned the man not to continue the fight, but he ignored the order. Jeffers drew his pistol, fired and killed Sutterfield.[164] Jeffers fled and was never arrested for the killing. Some said that after the shooting, Jeffers and Schipe started across the Sierra, and within a few days, Schipe had returned alone with Jeffers's horse, saddle, six-shooter and clothes, with no explanation given as to whereabouts of Jeffers.

In the summer of 1868, a valley badman named Jim Raines, who had served time in Alcatraz for robbing Chinese merchants,[165] was wanted for cattle and hog stealing. A posse of nine men, led by John Schipe, hunted for the wanted man. Some say that the group was not a posse at all but rather another band of outlaws that wanted to silence Raines. The men found Raines in a mountain meadow called Indian Basin, near what became the lumber camp known as Hume-Bennett Lumber Company. At nightfall, Schipe entered Raines's camp using the excuse that he was exhausted from following a bear all day. He asked if he could spend the night, and although Raines was suspicious, he allowed him to stay. After a few hours, Raines relaxed his guard, and the devious Schipe "got the drop on him." The rest of the armed men joined Schipe and his captive. The group found a nearby cedar tree with a wide-reaching limb, and there they hanged Raines, burying him nearby. J.H. Mankins, an early pioneer of Tulare County who knew both Jim Raines and John Schipe, claimed that Raines "died not from theft, but because he knew too much about the wrong-doings of others."[166]

In the 1860s, mountain man John Schipe settled in a little valley south of Millerton in Fresno County. For years, the area was known as Shipe's Valley and is now the area around Dunlap. From here, John Schipe visited Visalia and eventually died from three fatal gunshots. *State Geological Survey of California, 1873, Sacramento.*

By November 1868, Schipe was living with his American Indian wife at a cabin in a little valley (later called Shipe's Valley) in Fresno County. One day, he and his wife's younger brother packed a burro with gear and went gold prospecting into the Kings River Canyon. According to legend, the two followed the middle fork of the Kings River and, by chance, discovered a rock outcropping laced with gold. They broke off a chunk, put it into their pack and returned home.

On Tuesday, December 1, 1868, Shipe took his buckboard to Visalia. Some say that he went to assay his gold specimen, while others assert that he was looking for a business partner for his claim. Still others maintain that the heavy drinker traveled to Visalia as part of a normal "blowout" routine.[167] Regardless of his reason, Schipe was a regular in town, and he knew people, including Visalia city marshal John Williams.

Although details are sketchy about Schipe's actions that Tuesday, it is clear that while making his rounds in Visalia's saloons, trouble was not far away. The local newspaper reported the deadly event:

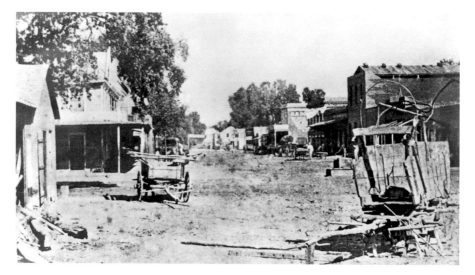

Visalia's Main Street in the 1860s shows a frontier town with dirt streets, abandoned wagons and primitive buildings. John Schipe would have been familiar with the scene, and he was shot and killed on this street, image circa 1863. *Annie R. Mitchell History Room, Tulare County Library, Visalia, California.*

Another unfortunate affair has transpired in our town resulting in the death of John Schipe at the hands of [Visalia] *Marshal Williams and Deputy* [Marshal] *McCrory. Schipe appears to have been intoxicated and boisterous, and when informed by Mr. Williams that he must be quiet or his arrest would become necessary, which advice was unheeded, and the Marshal attempted to take him into custody, when he resisted and threatened the officer. Being a large, powerful man, and dangerous while under the influence of liquor, the Marshal deemed it advisable to try peaceful means, and called up Schipe's friends, asking them to induce him to desist and avoid the arrest. This he also refused, continuing to act in a noisy and threatening manner. The Marshal deeming his detention now a matter of duty, called to his aid, Deputy* [Jim] *McCrory and a posse, and attempted to take Schipe and lodge him in jail, which he resisted, making such an assault as compelled them to fire upon and kill him.* [168]

After killing Schipe, the lawmen involved in the shooting surrendered, but it was determined that their actions were justified, so the men were released. The next day, Acting Coroner Arthur Shearer empaneled a coroner's jury. The men quickly returned their conclusion:

We, the undersigned, having been summoned and sworn by Arthur Shearer, acting coroner, to examine and report upon the dead body before us and find that the same is that of John Schipe, a German by birth, and as near as we can find, about 32 years old. We further find from the evidence taken before us, that he came to his death by three pistol balls inflicted upon him by John W. Williams and James G. McCrory, town marshal and deputy, while attempting to arrest deceased who resisted their authority. We also find that the killing occurred on Tuesday night, the 1st day of December, 1868.[169]

After the shooting, conspiracy theories became the talk of the town. One story claimed that Marshal Williams and Deputy McCrory killed Schipe because he wouldn't reveal the location of his gold mine. Another theorized that during his visit to Visalia, the drunken man had said too much to the wrong people about his secret gold discovery, resulting in his death.

But the violence connected with John Schipe did not end with his death. A few weeks after the incident, a man named Samuel Hall was drinking at the El Dorado Saloon. Jim McCrory, the saloon proprietor and deputy city marshal, argued with Hall about the Schipe killing. Angry words turned to gunplay, and McCrory shot Hall three times—though none was a life-threatening wound.

Mystery, too, became part of the Schipe story. The so-called Schipe Mine, if there actually was one, became a popular subject for speculation. For many decades, adventurers and treasure hunters searched the Kings River Canyon looking for the gold that may have played a part in the death of this Tulare County badman—a killer who was once described as the most dangerous man on the Pacific Coast.[170]

Notes

CHARLES REAVIS

1. *Visalia Weekly Delta*, July 11, 1889.
2. Ibid.
3. Ibid.
4. *Visalia Weekly Delta*, December 29, 1882.
5. *Visalia Weekly Delta*, July 11, 1889.
6. Ibid.
7. Ibid.
8. Ibid.
9. *San Francisco Call*, July 7, 1889.
10. *San Francisco Call*, July 6, 1889.
11. *Sacramento Daily Union*, July 9, 1889.

THE DESPERATE LIFE OF FRANK CREEKS

12. *Visalia Daily Delta*, February 27, 1902.
13. *Visalia Daily Delta*, March 1, 1902.
14. *Visalia Daily Delta*, April 22, 1902.
15. *Visalia Daily Delta*, May 4, 1902.
16. *San Francisco Call*, February 14, 1904.
17. *Visalia Daily Delta*, April 17, 1904.
18. *Woodland Daily Democrat*, August 27, 1915.
19. *Berkeley Daily Gazette*, October 17, 1914.

20. *Oakland Tribune*, October 18, 1914.
21. Supreme Court of California, *People v. Frank Creeks Criminal*, #1924, June 7, 1915.
22. *Woodland Daily Democrat*, August 27, 1915.

Jim McCrory

23. *Tulare Times*, December 28, 1872.
24. *Visalia Weekly Delta*, April 10, 1867.
25. San Quentin Prison Register, Convict #4860, James McCrory, California State Archives.
26. *Tulare Times*, December 5, 1868.
27. *Visalia Weekly Delta*, December 30, 1868.
28. *Visalia Weekly Delta*, April 6, 1870.
29. *Sacramento Daily Union*, October 26, 1870.
30. *Tulare Times*, December 28, 1872.
31. Ibid.
32. Ibid.
33. *Tulare Times*, January 4, 1873.
34. *Los Tulares* 146 (December 1984): 3.
35. *Visalia Weekly Delta*, December 26, 1872.

Ruggles Brothers

36. *Pen Pictures from the Garden of the World*, 310.
37. *Sacramento Daily Union*, March 23, 1877.
38. *Visalia Weekly Delta*, November 8, 1878.
39. Ibid.
40. *Daily Alta California*, November 3, 1878.
41. *Winters Advocate*, November 2, 1878.
42. *Visalia Weekly Delta*, November 8, 1878.
43. California State Archives, Pardon File, John Ruggles.
44. Ibid.
45. Ibid.
46. *Tulare County Times*, May 27, 1892.
47. *San Francisco Bulletin*, November 25, 1900.
48. *San Francisco Chronicle*, July 25, 1892.

49. *Visalia Morning Delta*, May 21, 1892.
50. *San Francisco Chronicle*, June 21, 1892.
51. *San Francisco Chronicle*, June 24, 1892.
52. *San Francisco Chronicle*, July 25, 1892.
53. Ibid.
54. *Los Angeles Times*, July 27, 1892.

JOSIAH LOVERN

55. *Visalia Times Delta*, September 7, 1937.
56. *Visalia Morning Delta*, June 14, 1896.
57. *Visalia Morning Delta*, December 15, 1892.
58. *Visalia Morning Delta*, March 7, 1893.
59. *Visalia Morning Delta*, March 20, 1896.
60. *San Francisco Call*, March 25, 1896.
61. *Sacramento Record Union*, March 24, 1896.
62. *Visalia Morning Delta*, June 20, 1896.
63. *San Francisco Call*, May 13, 1899.
64. *Visalia Times Delta*, October 29, 1932.

HOG ROGERS BECOMES FOOD FOR KING

65. *Sacramento Daily Union*, March 23, 1865.
66. Ibid.
67. Small, *History of Tulare County*, vol. 1, 372.
68. *Sacramento Daily Union*, July 20, 1865.
69. Hobbs, *Wild Life in the Far West*, 358.
70. *Visalia Weekly Delta*, July 19, 1865.
71. *Visalia Weekly Delta*, July 25, 1865.
72. Small, *History of Tulare County*, vol. 1, 372.
73. *Visalia Weekly Delta*, August 16, 1865.
74. *Visalia Weekly Delta*, September 6, 1865.
75. Hobbs, *Wild Life in the Far West*, 358.
76. *Visalia Weekly Delta*, August 1, 1866.
77. Tulare County Grand Jury Indictment, September 12, 1865.
78. *Visalia Weekly Delta*, October 4, 1865.
79. *Visalia Weekly Delta*, November 1, 1865.

Mason-Henry Gang

80. *Visalia Weekly Delta*, November 30, 1864.
81. Morgan, *History of Kern County*, 44.
82. Latta, *Tailholt Tales*, 200.
83. *Daily Alta California*, January 9, 1866.
84. Ibid.
85. Ibid.
86. *Visalia Weekly Delta*, December 21, 1864.
87. *Visalia Weekly Delta*, November 30, 1864.
88. Latta, *Tailholt Tales*, 152.
89. *Visalia Weekly Delta*, December 21, 1864.
90. Latta, *Tailholt Tales*, 214.
91. *Visalia Weekly Delta*, March 15, 1865.
92. *Visalia Weekly Delta*, April 12, 1865.
93. *Sacramento Daily Union*, July 24, 1865.
94. *Visalia Weekly Delta*, August 27, 1865.
95. *Visalia Weekly Delta*, December 19, 1866.
96. *Visalia Weekly Delta*, September 20, 1865.
97. *Visalia Weekly Delta*, April 25, 1866.
98. *Daily Alta California*, April 21, 1866.

James Wells

99. *Visalia Delta*, September 10, 1863.
100. Menefee and Dodge, *History of Tulare and Kings Counties*, 31.
101. *Sacramento Daily Union*, August 18, 1863.
102. *Visalia Delta*, August 13, 1863.
103. Ibid.
104. *Sacramento Daily Union*, August 10, 1863.
105. *New York Times*, August 13, 1863.
106. *Visalia Delta*, August 20, 1863.
107. Menefee and Dodge, *History of Tulare and Kings Counties*, 31.
108. *Visalia Delta*, October 29, 1863.
109. Menefee and Dodge, *History of Tulare and Kings Counties*, 32.

JIM MCKINNEY

110. Edwards, *Killing of Jim McKinney*, 11.
111. Doctor, *Shotguns on Sunday*, 55.
112. *Tulare County Times*, September 30, 1886.
113. Edwards, *Killing of Jim McKinney*, 14.
114. Ibid., 32.
115. *Visalia Daily Morning Delta*, April 26, 1894.
116. Edwards, *Killing of Jim McKinney*, 62.
117. *Tulare Times*, April 9, 1903.
118. Doctor, *Shotguns on Sunday*, 230.

EVANS AND SONTAG

119. Evans, *An Outlaw and His Family*, 4.
120. Harold L. Edwards, "Chris Evans' Early Troubles," *Los Tulares* 204 (June 1999): 1.
121. Koblas, *Robbers of the Rails*, 7.
122. Evans, *An Outlaw and His Family*, 42.
123. Ibid., 45.
124. Edwards, *Train Robbers & Tragedies*, 15.
125. *Hanford Weekly Sentinel*, February 28, 1889.
126. Menefee and Dodge, *History of Tulare and Kings Counties*, 148.
127. Edwards, *Train Robbers & Tragedies*, 29.
128. Koblas, *Robbers of the Rails*, 88.
129. Edwards, *Train Robbers & Tragedies*, 43.
130. *Visalia Daily Morning Delta*, June 13, 1893.
131. *Visalia Daily Morning Delta*, February 9, 1894.
132. *Visalia Daily Morning Delta*, February 21, 1894.
133. *Visalia Daily Morning Delta*, February 10, 1917.

KEENER AND DOWDLE

134. *Visalia Daily Morning Delta*, May 22, 1894.
135. *Visalia Times Delta*, July 14, 1951.
136. *Visalia Daily Morning Delta*, May 22, 1894.
137. Ibid.

138. Boessenecker, "John Keener Cashes In," *Old West*, 14.

139. *Visalia Daily Morning Delta*, May 22, 1894.

140. *Visalia Daily Morning Delta*, May 25, 1894.

141. *Visalia Daily Morning Delta*, May 22, 1894.

142. Ibid.

143. Boessenecker, "John Keener Cashes In," *Old West*, 18.

144. *Visalia Daily Morning Delta*, June 1, 1894.

HE WAS KNOWN AS BLOODY MORRIS

145. *Mariposa Gazette*, October 12, 1858.

146. *Visalia Weekly Delta*, February 24, 1877.

147. California State Archives, "Citizen Petition to Governor Weller pertaining to William Gouverneur Morris and His Unsuitability to be a Notary Public," 1858.

148. Menefee and Dodge, *History of Tulare and Kings Counties*, 93.

149. *Visalia Sun*, November 15, 1860.

150. *Visalia Weekly Delta*, November 3, 1860.

151. Tulare County Coroner's Inquest, No. 105, John Shannon, November 16, 1860.

152. *Visalia Sun*, November 22, 1860.

153. U.S. Grant Papers, December 1868, Morgan Library, Department of Literacy and Historical Manuscripts, New York.

154. Shumate, *Stormy Life of Major Wm. Gouverneur Morris*, 55.

155. *Tulare Times*, December 13, 1873.

156. Shumate, *Stormy Life of Major Wm. Gouverneur Morris*, 66.

157. Ibid., 92.

158. Ibid., 95.

159. *Sacramento Daily Union*, February 18, 1884.

160. Menefee and Dodge, *History of Tulare and Kings Counties*, 95.

JOHN SCHIPE

161. *Sacramento Daily Union*, May 25, 1859.

162. *Inyo Register*, September 20, 1906.

163. *San Francisco Daily Evening Post*, November 22, 1879.

164. *Visalia Weekly Delta*, August 30, 1865.

165. *Visalia Weekly Delta*, January 12, 1864.

166. *Tulare County Times*, July 29, 1915.

167. Ibid.

168. *Tulare Times*, December 5, 1868.

169. Tulare County Coroner's Inquest, No. 37, John Schipe, December 2, 1868.

170. *Tulare County Times*, July 29, 1915.

Bibliography

Boessenecker, John. *Badge and Buckshot: Lawlessness in Old California.* Norman: University of Oklahoma Press, 1988.

———. "John Keener Cashes In." *Old West* (Winter 1991): 14–18.

Boys, W. Harland, John Ludeke and Marjorie Rump, eds. *Inside Historic Kern.* Bakersfield, CA: Kern County Historical Society, 1982.

Brown, J.L. Brown. *The Mussel Slough Tragedy.* Hanford, CA: J.L. Brown, 1958.

Chalfant, W.A. *The Story of Inyo.* Bishop, CA: W.A. Chalfant, 1933.

Clough, Charles W., and William B. Secrest Jr. *Fresno County—the Pioneer Years: From the Beginnings to 1900.* Fresno, CA: Panorama West Books, 1984.

Doctor, Joseph E. *Shotguns on Sunday.* Los Angeles, CA: Westernlore Press, 1958.

Edwards, Harold L. *Train Robbers and Tragedies: The Complete Story of Christopher Evans, California Outlaw.* Visalia, CA: Tulare County Historical Society, 2003.

Evans, Eva. "An Outlaw and His Family." Unpublished manuscript, n.d.

Guinn, J.M. *History of the State of California & Biographical Record of the San Joaquin Valley, California.* Chicago: Chapman Publishing Company, 1905.

Harper's New Monthly Magazine, no. 390, November 1882, 872.

History of Fresno County California. San Francisco, CA: Wallace W. Elliott & Company, 1882. Reprint, Fresno, CA: Valley Publishers, 1973.

History of Kern County. San Francisco, CA: Wallace W. Elliott & Company, 1883. Reprint, Exeter, CA: Bear State Books, 2003.

Hobbs, Captain James. *Wild Life in the Far West: Personal Adventures of a Border Mountain Man.* Glorieta, NM: Rio Grande Press, Inc., 1969. Originally printed in 1872.

Hurst, Harry. *Alta Pioneers.* Dinuba, CA: Alta Advocate, 1924.

Koblas, John. *Robbers of the Rails: The Sontag Boys of Minnesota.* St. Cloud, MN: North Star Press of St. Cloud, Inc., 2003.

Latta, Frank F. *Dalton Gang Days.* Santa Cruz, CA: Bear State Books, 1976.

———. *Saga of Rancho el Tejon.* Santa Cruz, CA: Bear State Books, 1976.

———. *Tailholt Tales.* Santa Cruz, CA: Bear State Books, 1977.

Los Tulares. Tulare County Historical Society newsletter. Visalia, California.

Menefee, Eugene L. and Fred A. Dodge. *History of Tulare and Kings Counties California.* Los Angeles, CA: Historic Record Company, 1913.

Mitchell, Annie R. *The Way It Was: The Colorful History of Tulare County.* Fresno, CA: Valley Publishers, 1976.

Morgan, Wallace M. *History of Kern County California.* Los Angeles, CA: Historic Record Company, 1914.

Morrell, Ed. *The Twenty-fifth Man: The Strange Story of Ed Morrell.* Montclair, NJ: New Era Publishing Company, 1924.

O'Connell, Jay. *Train Robber's Daughter: The Melodramatic Life of Eva Evans, 1876–1970*. Northridge, CA: Raven River Press, 2008.

Official Historical Atlas Map of Tulare County. Tulare, CA: Thomas H. Thompson, 1892. Reprint, Visalia, CA: Limited Editions of Visalia, Inc., 1973.

Pen Pictures from the Garden of the World: Memorial and Biographical History of the Counties of Fresno, Tulare, and Kern, California. Chicago: Lewis Publishing Company, n.d.

Secrest, William B. *California Badmen: Mean Men with Guns*. Sanger, CA: Quill Driver Books/Word Dancer Press, 2007.

———. *Lawmen & Desperadoes: A Compendium of Noted, Early California Peace Officers, Badmen and Outlaws 1850–1900*. Spokane, WA: Arthur H. Clark Company, 1994.

Shumate, Albert. *The Stormy Life of Major Wm. Gouverneur Morris in California and Alaska*. San Francisco: California Historical Society, 1993.

Small, Kathleen Edwards. *History of Tulare County*. Vol. 1. Chicago: S.J. Clarke Publishing Company, 1926.

Smith, Wallace. *Prodigal Sons: The Adventures of Christopher Evans and John Sontag*. Boston: Christopher Publishing House, 1951.

Vandor, Paul. *History of Fresno County, California with Biographical Sketches*. Vols. 1 and 2. Los Angeles, CA: Historic Record Company, 1919.

NEWSPAPERS

Berkeley (CA) Daily Gazette
Bishop (CA) Inyo Register
Hanford (CA) Hanford Weekly Sentinel
Los Angeles Times
New York Times
Oakland (CA) Tribune

Sacramento (CA) Daily Union
Sacramento (CA) Record Union
San Francisco Bulletin
San Francisco Call
San Francisco Chronicle
San Francisco Daily Alta California
San Francisco Daily Evening Post
Tulare (CA) Times
Tulare County (CA) Times
Visalia (CA) Daily Delta
Visalia (CA) Daily Morning Delta
Visalia (CA) Delta
Visalia (CA) Morning Delta
Visalia (CA) Sun
Visalia (CA) Times Delta
Visalia (CA) Weekly Delta
Winters (CA) Advocate
Woodland (CA) Daily Democrat

Index

W

Y

Z

About the Author

Terry Ommen was born in Minnesota and spent his first ten years on the family farm. For health reasons, his father had to leave farming and moved the family west to the Los Angeles suburb of Hawthorne. Following high school graduation in 1965, he enlisted in the U.S. Army. For nearly three years, he served in the Military Police Corps in overseas and stateside assignments as a military policeman.

Ommen began his career with the Visalia Police Department in 1972 and, after twenty-five years of service, retired as a police captain in 1997. He has a bachelor's degree from Long Beach State University and a master's from Chapman University. Professionally, he is a graduate of the California Police Command College and the Federal Bureau of Investigation National Academy in Quantico, Virginia.

He enjoys learning about the Old West, especially the part that Tulare County played in creating it. For more than two decades, he has researched Tulare County history and has written about a broad range of local history

subjects. However, as a career lawman, he has a special interest in the early peace officers and the badmen who gave these men with badges so much grief.

The retired lawman has written hundreds of local history columns and articles for newspapers including the *Visalia Times Delta*, *Fresno Bee* and *Valley Voice*, as well as for *Direct* magazine. In addition, he authored a book in 2008 called *Then & Now Visalia*, and in 2011, he wrote *Christ Lutheran Church, a Gathering Place for a Half Century*. Currently, he writes an occasional historical column for the *Visalia Times Delta* called "This Place Matters." Since 2008, he has written and published a blog called "Historic Happenings" (www.visaliahistory.blogspot.com) that serves as a Visalia historical newsletter.

He is a member of the California Council for the Preservation of History (CCPH), Visalia Heritage, the Wild West History Association (WWHA) and the Tulare County Historical Society (TCHS).

In addition to his writing and research, he enjoys spending time and traveling with Laraine, his wife of forty-one years, daughter Lyndsay, son-in-law Chad and granddaughter Maggie Lee.